IMAGES
of America

McKees Rocks
and Stowe Township

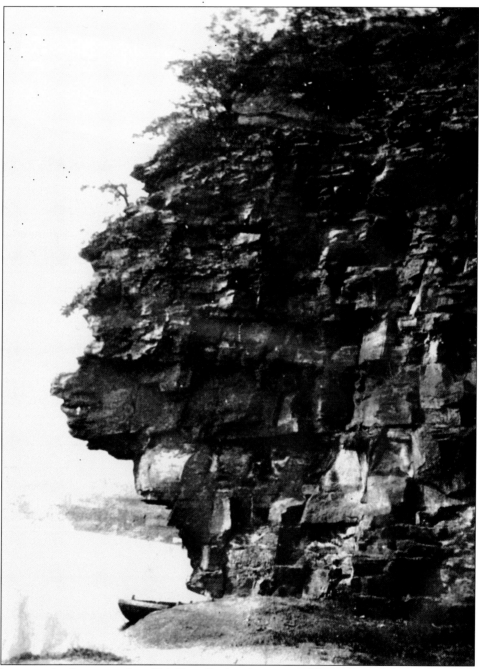

These are the famous rocks of McKees Rocks. A recognizable geological feature even back in George Washington's time, this rocky bluff formed an elevated canopy 100 feet above the banks of the Ohio River. The ancient Adena Indians built a large mound on top of these rocks starting around 250 BC. Some theorize that the name McKees Rocks originated when settlers at Pittsburgh's Point, aware of Alexander McKee's dwelling within sight of the rocks, used that name as a point of reference. (Mary Mancini Hartner.)

On the cover: Please see page 63. (Judy Salera.)

IMAGES
of America

MCKEES ROCKS
AND STOWE TOWNSHIP

Bernadette Sulzer Agreen
with the McKees Rocks Historical Society

ARCADIA
PUBLISHING

Published by Arcadia Publishing
Charleston, South Carolina

Printed in the United States of America

Library of Congress Control Number: 2008939952

For all general information contact Arcadia Publishing at:
Telephone 843-853-2070
Fax 843-853-0044
E-mail sales@arcadiapublishing.com
For customer service and orders:
Toll-Free 1-888-313-2665

Visit us on the Internet at www.arcadiapublishing.com

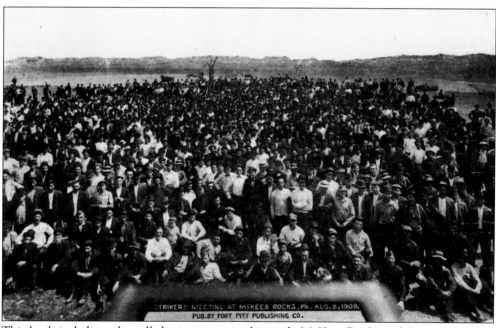

This book is dedicated to all the immigrants who made McKees Rocks and Stowe Township their home. (Tom Berilla.)

CONTENTS

ACKNOWLEDGMENTS

I would like to thank the members of the McKees Rocks Historical Society for their help in the making of this book. In particular, I would like to thank John Makar for lending his extensive knowledge of the history of McKees Rocks and Stowe Township and sharing his photographs. Unless otherwise noted, images in this book are from his collection. I would also like to thank Sandy Saban for cheering me on in this project, Cindy Gray for scanning oversized pictures and arranging the use of the Indian Mound photographs from the Carnegie Museum of Natural History, and Frank Stingone, president of the Pittsburgh and Lake Erie Railroad Historical Society, for permitting access to its archival photograph collection. Additionally, I would like to thank the McKees Rocks Community Development Corporation (CDC) and Taris Vrcek, executive director, for the use of images.

To the many individuals who shared their time, memories, and personal photographs with me, I would like to express my most sincere gratitude. I could not have done this book without you and your wonderful stories and photographs. Thank you. I tried to be accurate with the captions and if you find errors, please accept my apologies. To Martin Savalchak, thank you for responding to my last-minute request and sending your flood photographs so I could include them in this book.

I have come to realize that it is much easier to read a book than to write one. I have read and referenced Don Presutti's *McKees Rocks Centennial History* and Sinbad Condeluci's *Historic Portrait of McKees Rocks and Stowe Township* over and over while I worked on this project, learning something new each time. I also referenced Paul Stultz's ever-growing online repository, past articles by Rocky Phillips from the *Suburban Gazette*, and old editions of the *McKees Rocks Gazette*. So valuable is its information, when vintage issues of the *McKees Rocks Gazette* become available, historical society members feel as if we have discovered gold.

Finally, I want to thank my husband, Stewart, not only for his technical support and thoughtful care in backing up my photographs and documents to make sure I did not lose them before the book was finished, but also in realizing how important this project was to me and helping me achieve my goal. I treasure you and your constant love, support, and encouragement.

INTRODUCTION

I have wanted to put together an Images of America book for McKees Rocks and Stowe Township for a long time. My motivation was purely personal. My grandparents emigrated from Austria-Hungary to McKees Rocks early in the 20th century, and I have spent more than a decade researching my genealogy. In 2007, I visited the land of my ancestors, a little German village just inside the Hungarian border. My grandparents, along with thousands of other immigrants, left old Europe behind and came to settle, in of all places, McKees Rocks. Why, I had wondered, did they choose this town, and how did McKees Rocks look when they arrived a century ago?

What is known today as McKees Rocks and Stowe Township originally belonged to Moon Township, one of the seven original townships in Allegheny County, formed in 1788. Later they became part of Fayette Township in 1790 and then part of Robinson Township when it was formed in 1801. Stowe Township, named after Judge Edwin H. Stowe, came into existence in 1869. In 1892, McKees Rocks separated from Stowe Township and was incorporated as an independent borough.

Chartiers Creek winds from its headwaters in Washington County through Allegheny County, where it meets the Ohio River at McKees Rocks, three miles west of the Point at Pittsburgh. The creek was named after Pierre Chartiers, a trapper of French and Native American parentage who established a trading post at the mouth of the creek in 1743. In the 1700s, the Shawnee and then later the Delaware Indians also established villages here.

In 1753, on the recommendation of Christopher Gist of the Ohio Company of Virginia, George Washington inspected the mound site as a possible location of a fort but decided it offered a less strategic option than did the Point of Pittsburgh. It was during this time frame when Washington, just 21 years old, met the famous Delaware Indian warrior chief Shingiss and Seneca leader Guyasuta at the "Indian Mound" in 1753.

By the time Alexander McKee would host George Washington at his eight-room log home near the mouth of Chartiers Creek in 1770, he owned most of the land in McKees Rocks by virtue of a land grant in 1769. Soon talk of revolution would ultimately lead Washington to forge a new nation and Alexander McKee to cling to the crown. Siding with the British, McKee fled to Detroit. James McKee assumed ownership of the property and lived there until his death in 1835. The deed transferred in 1836 referred to his property as that of James McKee of McKee's Rocks.

In 1879, the Pittsburgh and Lake Erie Railroad (P&LE), formed four years earlier, began operation and made McKees Rocks its maintenance hub. The availability of both the railroad and the river made McKees Rocks a very desirable location to build a factory. By 1880, industries

began replacing farmland, and in a time frame of only 20 years, from 1880 to 1900, the combined population of McKees Rocks and Stowe Township soared from 867 to 6,352. Unbelievably, by 1910, the population reached 14,702. Immigration from eastern and central Europe was directly responsible for the rapid rise in population. Of the 14,702 people living in McKees Rocks in 1910, 6,073 were foreign born.

The first decade of the 20th century was a time of both conflict and growth in McKees Rocks and Stowe Township. The bloody Pressed Steel Car strike of 1909 brought safer working conditions and some concessions from the company to the workers. The growing population precipitated the need for more churches, schools, and homes. By 1915, there were 750 businesses listed in the Polk Directory. McKees Rocks quickly crowded its one square mile of land with hundreds of homes, businesses, and factories. Development in Stowe Township was not far behind, and by 1898, developers had begun purchasing farmland and were selling lots in Norwood, West Park, and Herrington Hill. Within the span of 20 years, what had been farms in Stowe Township were now major residential areas.

With the photographs in this book, I have tried to chronicle the early history of McKees Rocks and Stowe Township, illustrate certain aspects of life in bygone years, and kindle a connection to our past. The next time you drive down Chartiers Avenue, past the McDonald's, I hope you can picture the old McKee School with its black wrought-iron fence that once stood there. On your next trip across the McKees Rocks Bridge, imagine how it looked in 1936 when crowds of people huddled together on the ramps, watching the rescue drama unfold in the flooded streets below. And, the next time you drive down River Road near Crivelli Chevrolet, think about the thousands of hopeful immigrants as they stepped off the train at the McKees Rocks station a century ago. I know I do.

—Bernadette Sulzer Agreen

One

SACRED GROUND AND FAMOUS FOOTSTEPS

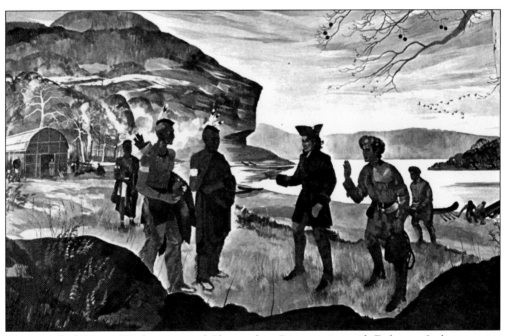

This mural of George Washington and Christopher Gist meeting with Delaware Indian warrior Chief Shingiss and Seneca leader Guyasuta at the "Indian Mound" in 1753 graced a wall of the former Pittsburgh National Bank on Chartiers Avenue. Although Washington rejected Gist's suggestion to build a British fort at the mound site in McKees Rocks, his historic footsteps along the mound and the muddy creek bed gave credence to this region's burgeoning value and its vital role in the making of the United States.

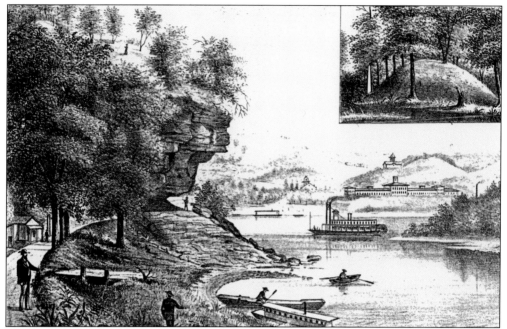

On top of the promontory overlooking the Ohio River, the ancient Adena people built what became known as the McKees Rocks Mound. Thousands of sacred Native American burial mounds such as this one, started as early as 250 BC, were visible in Ohio and Mississippi river valleys during the 18th and 19th centuries. Smaller mounds existed nearby in Green Tree and on Grant's Hill, Pittsburgh. An artist sketched this image of the McKees Rocks Mound area as it looked in 1876. (Theresa Sulzer.)

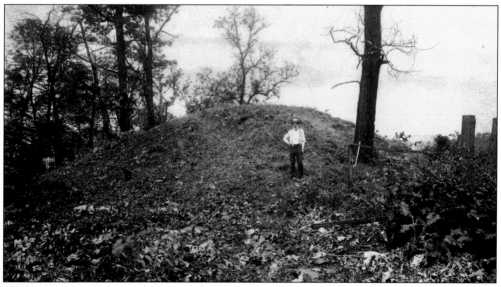

The McKees Rocks Mound, a dome-shaped earthwork, was 16.5 feet tall, 85 feet in diameter, and 266 feet in circumference. Prof. Frank H. Gerrodette, director of Pittsburgh's Carnegie Museum, opened the mound on July 18, 1896, after obtaining permission from McKee family heirs who owned the property. Mounds, like the one in McKees Rocks, were always built a level above the riverbed. (Carnegie Museum of Natural History.)

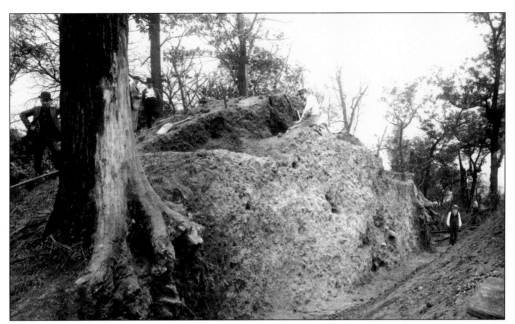

On August 1, 1896, two skeletons were excavated along with arrowheads and pottery. The following week, the remains of two ancient fireplaces were discovered containing stones, shells, and ashes of charcoal. Later that week, a female skeleton was found in a sitting position, which was consistent with burial practices of ancient Britons and Greeks. Throughout late summer of 1896, skeletons were taken from the mound almost daily. News of the excavated discoveries in the Pittsburgh newspapers not only created public interest but also enticed prominent scientists of the era, such as Prof. W. J. Magee of the Smithsonian Institute and Dr. Frederick Putnam, curator of the Peabody Museum at Cambridge, to personally visit the dig site. Some 33 skeletons were eventually removed and are currently in storage at the Carnegie Museum. (Carnegie Museum of Natural History.)

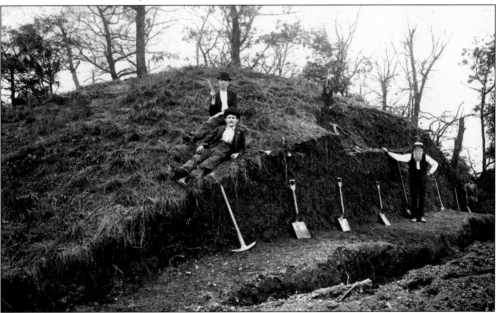

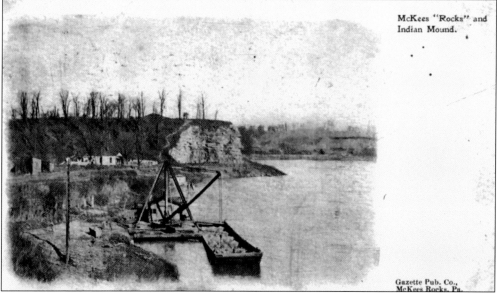

McKees "Rocks" and Indian Mound.

Gazette Pub. Co., McKees Rocks, Pa.

People conveniently refer to the Indian Mound as the entire hill on which the mound was built; however, the Indian Mound, a small knoll, sits at the far end of the hill above the rocks. These two photographs show the changing profile of the rocks and the relative position of the Indian Mound to the edge of the rocks. In the photograph above, taken around 1900, the mound sets back from the edge of the quarried rocks. However, by 1910, with significant rock removed to make way for the Pittsburgh, Chartiers and Youghiogheny railroad (PC&Y), the mound is closer to the edge. A spiritual constant in McKees Rocks history, the Indian Mound served as a backdrop to strikes, floods, and countless social and political gatherings. Although the site never achieved national park status, as proposed by Congressman James Fulton in 1946, it was recognized in May 2002 with a Pennsylvania historical marker. (Above, Tom Berilla; below, P&LE Historical Society.)

Two

A RAILROAD
BUILDS A TOWN

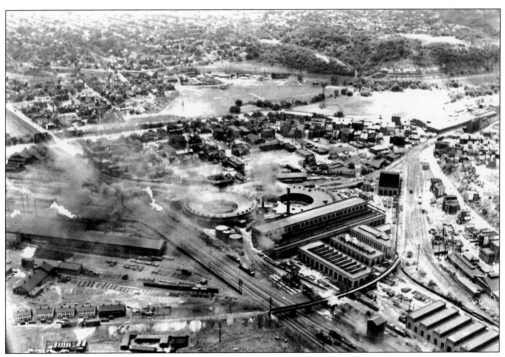

The opening of the Pittsburgh and Lake Erie Railroad (P&LE) in 1879 and the decision to make McKees Rocks its repair and maintenance center in 1888 set off an industrial gold rush. With the railroads so easily accessible, especially the P&LE, entrepreneurs came to McKees Rocks and built mills, foundries, and businesses. Immigrants arrived in McKees Rocks by the thousands. By 1910, the population reached 14,702. Of those 14,702 residents, 42 percent were foreign born.

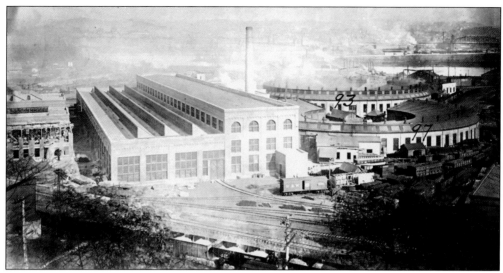

In 1888, the P&LE decided to establish a major repair and maintenance facility in McKees Rocks. On almost 100 acres of Ohio River flood plain, the P&LE built an extensive complex of redbrick buildings and wood-framed shops. The large two-tiered building next to the powerhouse smokestack is the machine and erection shop. Between the machine and erection shop and the PC&Y tracks, the P&LE located the boiler and tank shop, the blacksmith shop, and the storehouse. Sitting on the other side of the machine and erection shop were two colossal roundhouses where many P&LE steam locomotives were built and serviced. A large paint house and freight house were also nearby.

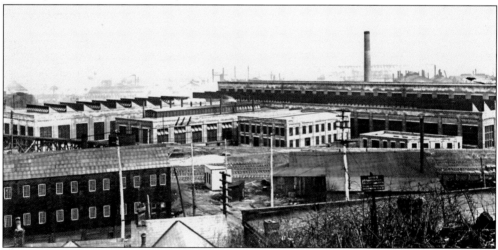

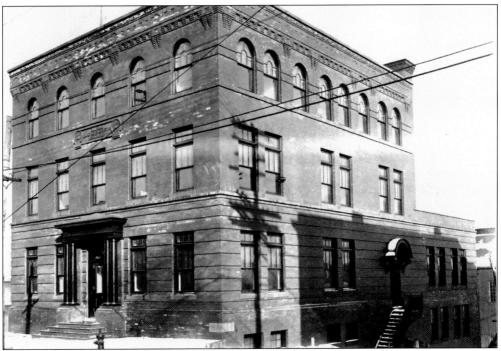

Built in 1905, this 21-room redbrick building located at 400 Island Avenue has served as a P&LE office building, a YMCA facility, and a restaurant. In 1914, it temporarily housed the sophomore class of the McKees Rocks High School. The freshman class reported to the Curtin School, while the senior class reported to the McKee School. All three classes were reunited in the new Ellsworth School in 1915. There was no junior class since high school was a three-year program.

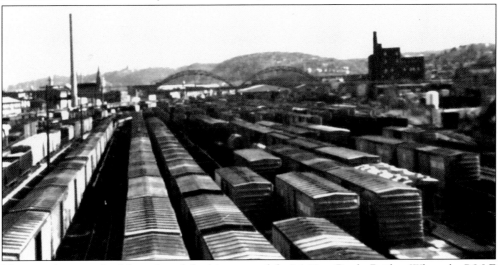

Here is a photograph of the rail yards looking toward the McKees Rocks Bridge. When the P&LE started operation in 1879, it had only 89 miles of track. Yet it was nicknamed the "Little Giant" due to the extraordinary amount of tonnage it moved when compared to the actual number of miles it traveled. Transporting coal, coke, iron ore, limestone, and steel for Pittsburgh's mills, the P&LE grew and prospered. When the mills disappeared in the early 1980s, the P&LE declined and was finally sold in 1992.

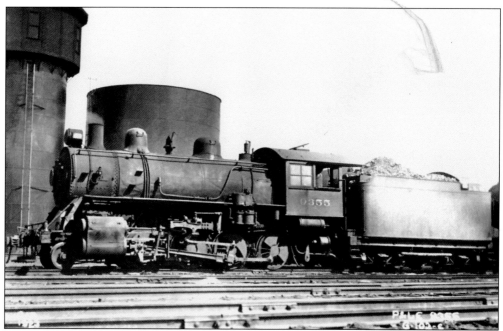

The photograph above of a steam engine dates from 1923. Steam locomotives powered the railroad industry for many years. The P&LE owned several types of steam locomotives. The P&LE had the distinction of receiving the last steam locomotive built by the American Locomotive Company. Although steam locomotives continued to grow in size, weight, and power during the 1940s, they were eventually replaced with the diesel locomotive in the 1950s. The photograph below, taken in 1946, with the Enterprise Hotel and train station in the background, captures both a steam engine and diesel engine on the track. (Above, P&LE Historical Society; below, Richard Hunter, photograph by J. J. Young.)

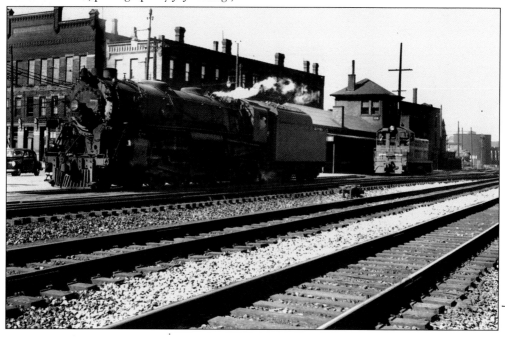

The photograph above features an engine that was built in 1891 for the PC&Y. The PC&Y was a local railroad, formed in 1881 by the Harmony Society to service their mines near Bridgeville. The PC&Y was bought jointly by the P&LE and the Pennsylvania Railroad (PRR) in 1891. Its landmark trestle across Chartiers Avenue was built in 1912. In the photograph below, the P&LE roundhouse provides a backdrop for a steam engine used by the PC&Y, which was built by ALCO-Brooks in 1897. (Frank Stingone.)

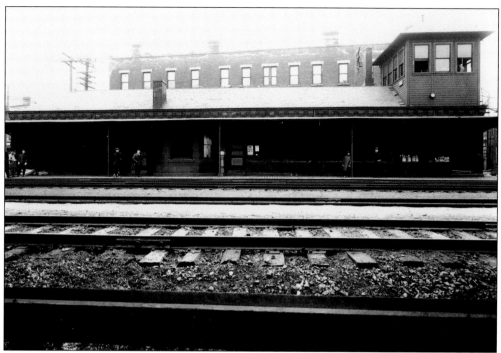

Here are two views of the rarely photographed McKees Rocks train station. The photograph above shows the P&LE train station around 1915 with the grand Enterprise Hotel in the background. During the heyday of its passenger service, from 1910 to 1930, thousands of emigrants ended their long journey from European ports here at the train station. One imagines they were welcomed by a brother, uncle, or cousin who had already made the same journey before them. The photograph below shows the station as it looked in 1949, just a few years after war's end when hundreds of families reunited here with their loved ones who had served in the armed forces. This is indeed historic ground in McKees Rocks. The train station is believed to stand on what was once the location of Alexander McKee's homestead, where he entertained George Washington in 1770. Today Crivelli Chevrolet is near this site. (Below, Richard Hunter.)

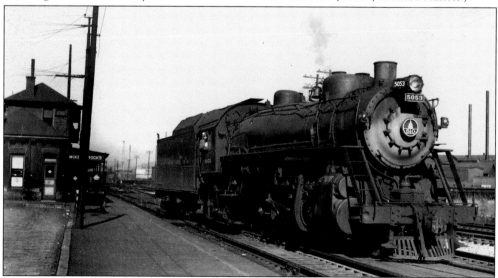

Three

COMING TO AMERICA

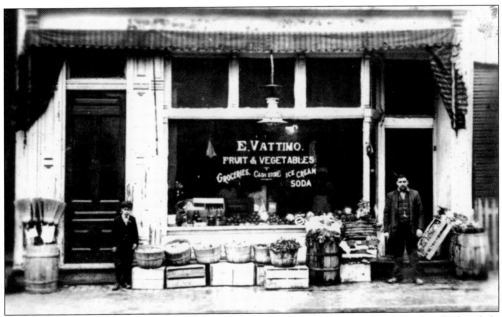

According to Vattimo family history, Eugenio Vattimo served as a palace guard in Italy while his wife, Marie, was a gifted equestrian. Seeking a better life in America, they came to McKees Rocks and opened the grocery store at 518 Island Avenue around 1910. Working hard, they raised a family, and like so many immigrants who arrived from Europe around 1900, they became a part of the American dream. (Bill Vattimo.)

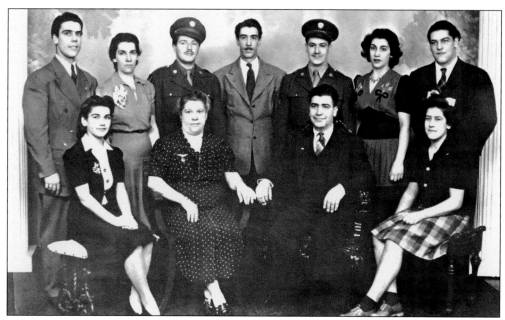

Gennarina and Antonio Condeluci emigrated from Italy to America in the early 1900s. The couple and their growing family went wherever Antonio could find work. In 1918, they settled down for good in Stowe Township. In 1944, brothers Sam and Sinbad bought lots on a 4.5-acre hill so family generations could be together. This 1943 photograph shows the original Condeluci family. From left to right are (first row) Betty, Gennarina (mother), Antonio (father), and Jeanette; (second row) Sinbad, Mary, Frank, Sam, William, Natalie, and Orlando. (Jan Condeluci Uhler.)

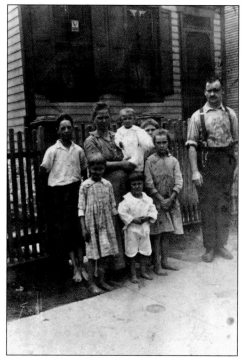

Franz Koller and his wife, Teresa Weber, had a total of 13 children; 8 lived to adulthood. Franz, also called Ferdinand, came to McKees Rocks and soon found work in the steel mills. Standing in front of their house at 851 Railroad Street in 1919 are Franz and Teresa Koller with their children. From left to right are (first row) Theresa, Harry, Gizella, and Franz; (second row) Karl, Teresa (holding Arthur), and Helen. (Gloria Koller Dorish.)

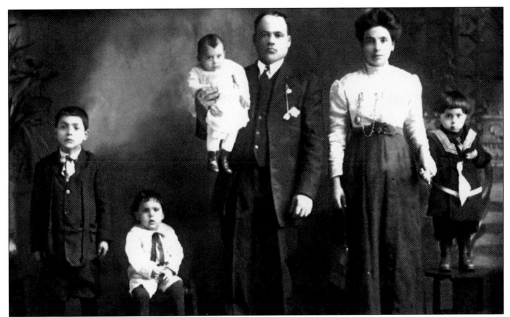

Like the Crivelli and Gargaro families, the Mancini family departed from Sante Eufemia Maiella in the Abruzzi Mountains of Italy for America. Frank Mancini and his wife, Maria, ran a grocery at 838 Island Avenue for many years. Jimmy Mancini, one of the Mancinis' seven children, founded Mancini's Bakery in 1926. From left to right are Jimmy, Nick, Frank (holding Mike), Maria DiPietrantonio (pregnant with Albert), and Tony. (Mary Mancini Hartner.)

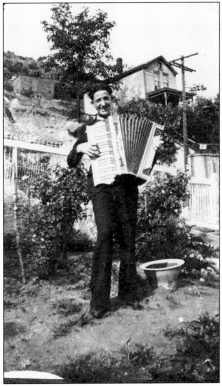

It is hard not to smile when looking at this 1930s photograph of Vincent Gargaro. Standing in the backyard of the Gargaro family home at 901 Benwood Avenue, teenager Vince happily demonstrates his musical talents with a newly arrived accordion from Italy. For many years, Vince, along with his brothers, Isadore and Anthony, entertained family and friends at weddings, nightclubs, and Italian feasts with their accordion, trumpet, and saxophone. (Nick Gargaro.)

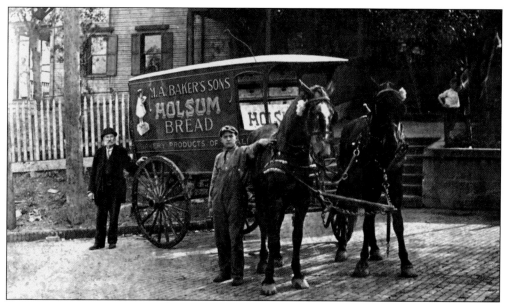

Michael A. Baker (left), the father of the seven Baker brothers and grandfather of Paul Baker, the founder of Jenny Lee Bakery, delivered baked goods to homes and stores with one wagon. Here he stands in front of Mann's Hotel with his son, William, in 1907. Michael was born in Bad Orb, Germany, in 1852. He opened his first bakery and a grocery store in the West End. After 32 years in business, Michael built a new house at 715 School Street in McKees Rocks. (Jim and Pat Baker.)

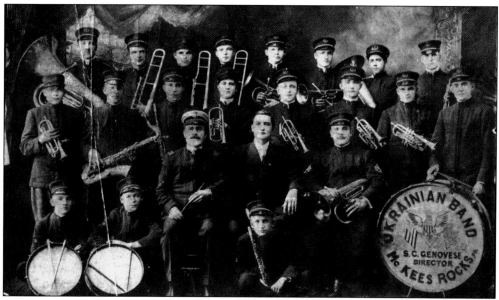

Music was integral to everyday life in the ethnic neighborhoods of McKees Rocks and Stowe Township. Every church and nationality had its band that played at weddings and funerals. John Hopay Sr. appears in the second row, fifth from the left, holding a trumpet. Interestingly, the band's director, Salvatore C. Genovese, is of Italian, not Ukrainian descent. An excellent musician, stern taskmaster, and Norwood barber, Genovese also directed the Stowe-Rox Band. (John Hopay.)

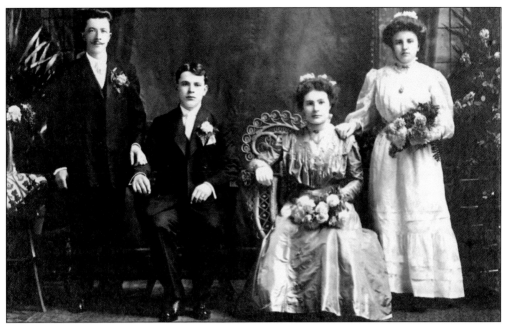

When Rudolph Diecek married Julia Keppel in 1909 at St. Mary's Church, he was a young widower with a one-year-old son. Franz Schrei and Anna Wagner also married later in 1909. When Franz died in 1922, Anna had little choice but to entrust her two small children to the nuns at St. Joseph's Orphanage and go to work. The family eventually reunited, and Anna remarried, moving her family to Chicago. From left to right are Franz Schrei, Rudolph Diecek, Julia Keppel, and Anna Wagner. (Anna Schrei Steiner.)

This is a c. 1917 photograph taken of Mary and Philip Bressler, who lived at 1223 Holmes Street for many years. Family and friends remember stories that Philip told of working on the construction of the Panama Canal. Daughter Helen joined the Sisters of Divine Providence and took the name Sister Alfreda. Standing with the couple are their children, from left to right, Edward, Helen, and Albert. (Roberta Rennekamp.)

This photograph of John and Mary Lesko with children, John, Vincent, and Mary was taken in 1928. In 1921, she packed up their American-born children for a visit to Slovakia while John continued working in the mill. However, due to the quota law passed in 1921, Mary was unable to return to the United States. It took seven years for John to become a naturalized citizen, making his wife eligible to apply for a visa and return home to McKees Rocks. (Mary Sulzer.)

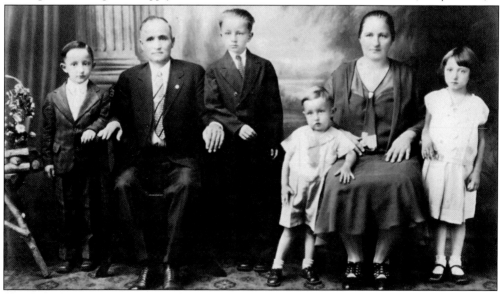

When Michael Sisko left his home in the Carpathian Mountains, he promised his sweetheart that he would return to marry her. Earning money working at Shenango, Michael made good on his promise. Anna Capovchak and Michael Sisko married in Czechoslovakia, and again he left his sweetheart until he could afford her trip to America. In 1921, his 23-year-old bride arrived, and together they made a life for themselves on Gardner Street. From left to right are Charles (twin), Michael (father), Michael, John, Anna Capovchak (mother), and Anna (twin). (Sandy Sisko Saban.)

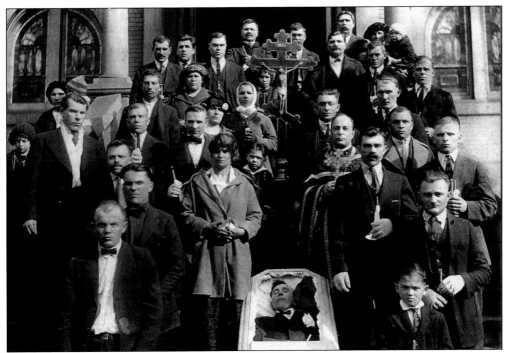

This photograph was taken on the steps of St. Nicholas Russian Orthodox Church in 1914. Because of inheritance laws in Russia, it was often customary to take a photograph of a funeral in order to prove that a person was really deceased. Also a photograph would provide a record of which family members and mourners attended the funeral. Often the deceased was propped up in his casket, surrounded by family and friends, when the photograph was taken. The deceased is of the Zacharias Stefantsov family. (Tracey Welsh Pedersen.)

The Pressed Steel Car strike of 1909 was one of the bloodiest battles in labor history as well as an inspiring example of working-class solidarity. In July 1909, 5,000 workers staged their first strike against low wages and dangerous working conditions. Management retaliated by bringing in scab laborers, building a stockade around the plant, and manning it with armed guards. This vintage postcard illustrates the makeshift stockade surrounding the plant.

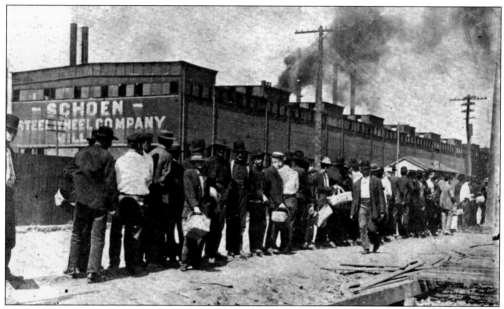

The strikers were assisted by the International Workers of the World (IWW), a radical labor union. For five weeks during the summer of 1909, strikers, replacement workers, company officials, and police met, argued, and occasionally skirmished. Striking workers, out of money, lined up for bread (above). On August 21, county sheriff Harry Exley and his deputies removed furniture and forcibly evicted workers from their Presston houses (below). That evening the IWW held a meeting in a field near the Indian Mound, and the next day, the situation turned bloody. On August 22, a state constable shot and killed a striker. Exley was fatally shot in a gunfight. For two hours, strikers and state troopers battled, firing over 500 shots. At least 12 men were killed, and upward of 50 were injured. By September, workers did win some concessions, including safer working conditions and restored wages.

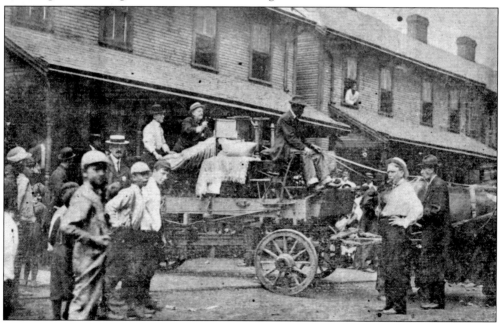

Four

EARLY DAYS

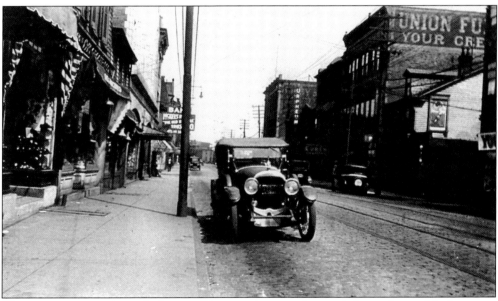

This scene captures the early days on Chartiers Avenue. Automobiles are few and far between. Sidewalks offer a wide promenade for shopping, strolling, and just getting from place to place. The streets are equipped with trolley tracks, and not a horse or wagon is in sight. The "Old Reliable," as the McKees Rocks Trust Company advertised, was also known as the Bank of McKees Rocks. It moved to this prime location in April 1912; the Orpheum Theater opened its doors in October 1923. (Bob DiCicco.)

This c. 1900 photograph exemplifies the formal dress style of the times. Frederick Sonnet and his wife, Margaret Yunkas Sonnet, were married in Reiskirchen, Germany, in 1880 and settled in McKees Rocks the following year. Frederick was a charter member of the Knights of St. George at St. Mary's Church, as well as the church's choir director for 20 years. The Sonnets lived at 4 Alice Street and had seven children. Several of their adult children appear in this photograph. (Roberta Rennekamp.)

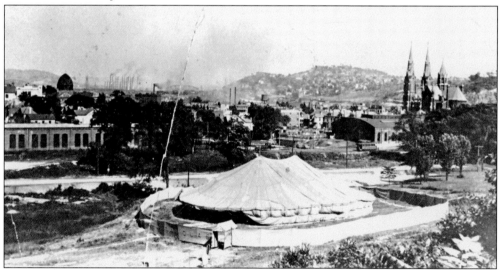

Tent chautauquas flourished in the United States from 1904 to the mid-1920s, appearing in over 10,000 communities. These summer traveling shows would pitch their big brown tent and entertain the community with speakers, musicians, and preachers for about a week. This is a photograph of a chautauqua in McKees Rocks, located in the area of Amelia and Progress Streets. Theodore Roosevelt reflected that chautauquas were "the most American thing in America." With the coming of radio, movies, and automobiles, the chautauqua movement declined.

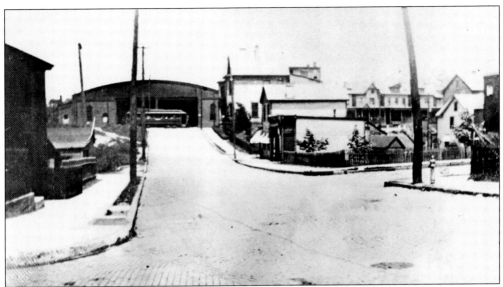

The West Park Car House of the Pittsburgh Railways Company was a maintenance and storage facility for trolleys until it closed in 1931. After that, it became more of a trolley junkyard. In 1942, a Pittsburgh newspaper reporter, looking for suitable scrap iron for war materials, described the carbarn as "a scrap collector's dream" with enough scrap iron to create a fleet of tanks. The carbarn was demolished in 1951. Foodland Market stands on the site.

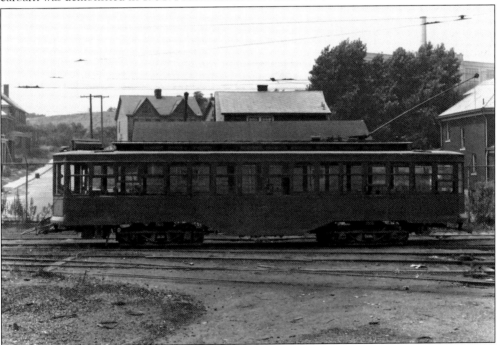

The Pittsburgh Railways Company, formed in 1902, operated four trolley runs in McKees Rocks and Stowe Township: the Island Avenue No. 25, the West Park No. 26, the Schoenville No. 24, and the Sewickley No. 23. With Miles Bryan High School in the background, this trolley photograph was taken around 1930. (Pennsylvania Trolley Museum Collection and John Makar.)

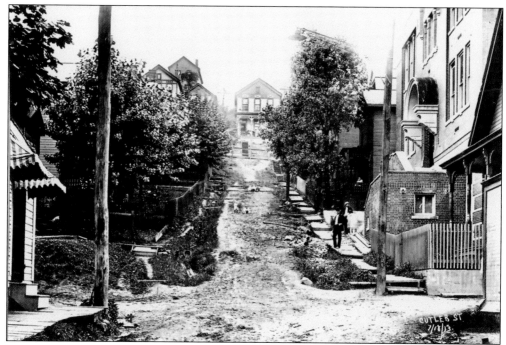

This image of Cutler Street, with dirt road and plank sidewalks, dates from 1913. The new SS. Cyril and Methodius Roman Catholic Church, seen on the right, had just been completed. The building served as a church and used the upper floors for the school. The SS. Cyril and Methodius Parish was organized primarily for Catholics of Polish origin. From April 1910 until the present church building was completed, parishioners attended mass in Lithuanian Hall on Locust Street. (Sue Homer Bennardo.)

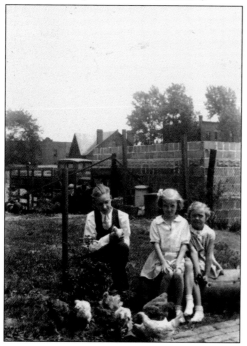

Keeping a chicken coop in the backyard was a common sight in and around the local neighborhoods. In this late-1920s photograph, from left to right, John, Roberta, and Ruthie Rennekamp are sitting in the backyard of their new house on First Street, near the West Park Car House. Roberta recalled that the chickens were not always friendly. Once a chicken bit her sister, Ruthie, on the lip. (Roberta Rennekamp.)

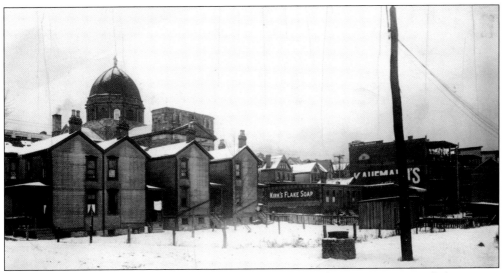

This serene winter photograph, taken in January 1917, shows a snowcapped dome atop St. Francis de Sales Church. Painted billboards advertising Kirk Flake Soap and Kaufmann's Department Store are visible. Taken from May Avenue, this photograph shows the buildings on the left that were later demolished to make way for the construction of the new McKees Rocks Post Office in 1927. (McKees Rocks Post Office.)

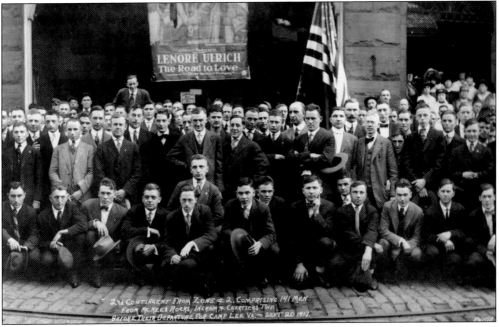

In 1917, when the United States entered World War I, 141 men from McKees Rocks, Ingram, and Chartiers Township gathered in front of the McKee School and the old Liberty Theatre, which was housed inside Fraternal Hall. On September 20, 1917, Mahan and Wright Photography Studio made a large panoramic photograph to commemorate the men's departure for Camp Lee, Virginia. This is a small portion of the photograph, which featured the 2nd Contingent from District No. 2. After the war, Burgess Louis Hamilton of McKees Rocks proclaimed a half-holiday, and all three communities celebrated with a huge parade. (Dave Dietz.)

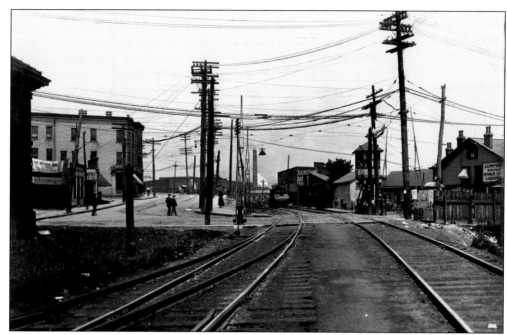

Chartiers Avenue was the main thoroughfare into the business district of McKees Rocks. These two 1910 photographs offer interesting views, east and west, of the intersection of Chartiers and Island Avenues prior to the building of the PC&Y trestle in 1911. Looking east, in the photograph above, Island Avenue winds past the P&LE buildings and turns right, crossing the PC&Y tracks. Notice the guard tower and the crossing gates that would temporarily halt traffic while the railroad cars rumbled by. These safety features, gates and tower, were a recent addition in this photograph and did not exist prior to 1904. Looking west, the photograph below offers a better look at the guard tower and switching lights. The Commonwealth Trust Company, built in 1901, is clearly visible to the right of the photograph along with the spires of St. Mary's Church. (P&LE Historical Society.)

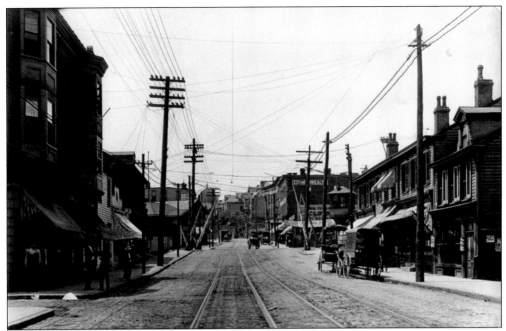

Looking north in the c. 1910 photograph above, visible in the distance is the dome of St. Francis de Sales Church. The Commonwealth Hotel, built in 1898 and owned by justice of the peace Miles Bryan, is well marked. Canvas awnings drape the businesses along the route, and horse-drawn wagons are still the common mode of transportation. Looking south in the photograph below, one of the first electric trolleys approaches the intersection underneath an aerial web of wires. Not yet gracing this Chartiers Avenue street scene are two frequently photographed financial landmarks, the First National Bank of McKees Rocks and the Bank of McKees Rocks. Although both banks were operating in 1910 elsewhere, construction of the Chartiers Avenue structures had not yet begun. (P&LE Historical Society.)

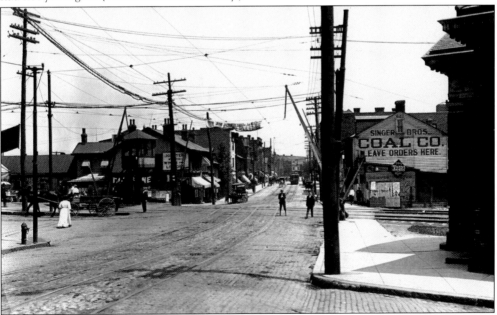

Along with the soaring steeples of St. Mary's Church and the graceful dome of St. Francis de Sales Church, the PC&Y railroad trestle is a visual landmark in McKees Rocks. Construction began on the trestle in the summer of 1911. In this photograph, taken on October 15, 1911, construction of the trestle is at the halfway point; one track is raised to the trestle while the other track remains at street level. (P&LE Historical Society.)

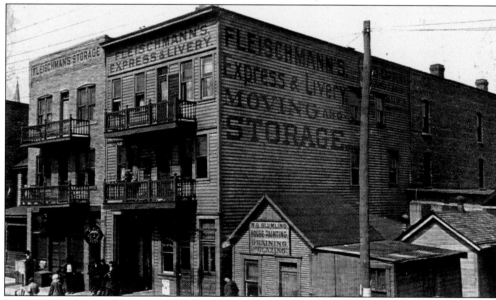

In 1893, William and George Fleischmann established Fleischmann's Express and Livery, Moving and Storage Business at 734 Thompson Avenue. Like U-Haul today, the company rented all sizes of wagons for hauling. In addition, the company delivered packages and trunks, making two trips daily to Pittsburgh, West End, Elliot, Esplen, and McKees Rocks. George Fleishmann later started the first motortruck service in McKees Rocks. Clyde Sample acquired Fleischmann's business in 1921. (Terri Angell.)

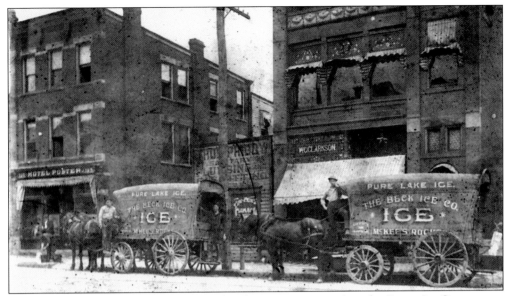

Before refrigerators, consumers looked to local ice companies such as the Singer Ice Company to keep food cold. In 1889, Louis Singer erected a large ice plant near Furnace Street and produced 95 tons of ice annually. Other ice companies also existed. This vintage photograph shows two ice wagons belonging to the Beck Ice Company parked on lower Chartiers Avenue. Ulrich Beck of 739 Mary Street ran an ice business around 1907. (Sue Homer Bennardo.)

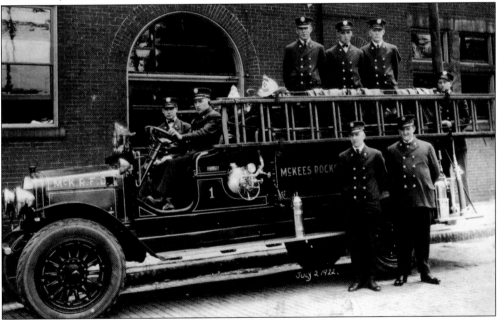

This 1922 photograph of the McKees Rocks firemen was taken on the Linden Street side of the old municipal building. The fire alarm was sounded on the P&LE shop whistle. Long blasts indicated the district; short blasts indicated the location of the fireplug. Two long blasts of the whistle indicated that the fire was out. The McKees Rocks Fire Department went to an all-paid force in 1922, which was maintained until May 1983 when it was replaced with all volunteers. (McKees Rocks Fire Department.)

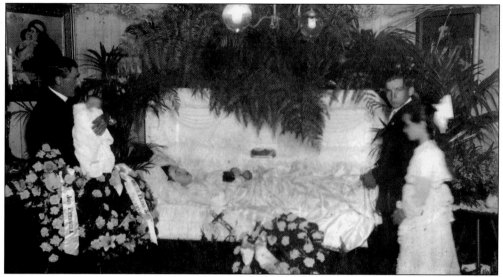

A funeral director came to the house and helped grieving families arrange a home viewing in the early 1900s. After delivering the casket to the house, he would transform the family parlor into a funeral parlor by setting up chairs, hanging drapes, and arranging flowers. A wreath with black ribbon was hung on the door to let the community know that the family in this house was in mourning. In this photograph, a family grieves for a young wife who died in childbirth. (McDermott Funeral Home.)

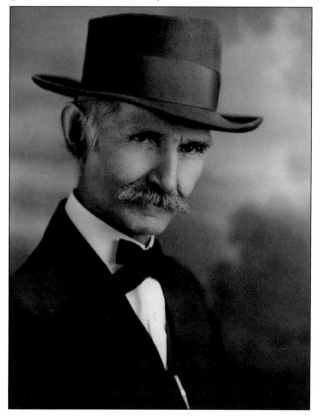

Bernard McDermott, pictured here, was born in 1854 and died in 1935. Together with his brother Patrick, he established a funeral home in nearby Carnegie. In 1905, the two brothers opened a branch in McKees Rocks on Island Avenue and, after the ambitious 1907 "Raising of Chartiers Avenue," moved the funeral business to a new building at 531 Chartiers Avenue, currently occupied by Dave Dietz Florist. In 1942, a new funeral home was constructed at 1225 Chartiers Avenue. (McDermott Funeral Home.)

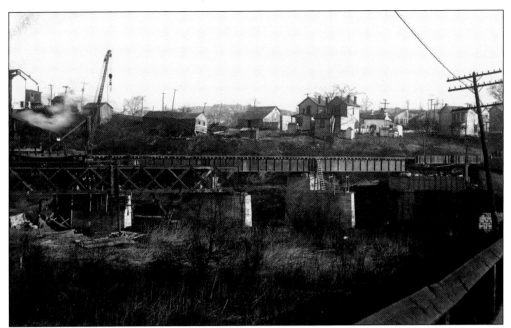

This vintage photograph shows the PC&Y bridge over Chartiers Creek being replaced by the PC&Y Bridge No. 1B in 1911. The back of the Mann's Hotel is visible in the top left of this photograph along with other long-gone structures that lined upper Chartiers Avenue. The Norwood Plan can be seen in the far distance. (P&LE Historical Society.)

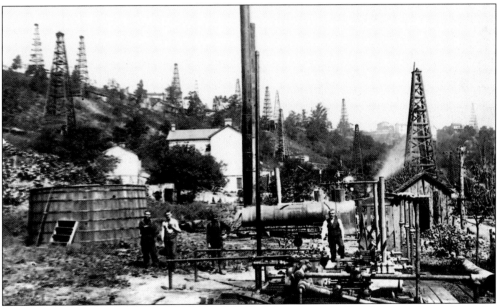

This 1890s photograph of Duff's Station, just below Mann's Hotel, was taken when the excitement of oil drilling reached its peak. S. D. Robison, C. W. Robison, Wynne Sewell, and Arthur Kennedy owned seven derricks, all located on property they leased from the Beck family. A *Pittsburgh Post* article dated July 31, 1890, described how one derrick, producing 5,000 barrels a day, dumped hundreds of barrels of oil into Chartiers Creek. They simply were not prepared for such a gusher. The Beck family received $700 daily in royalties. (Sue Homer Bennardo.)

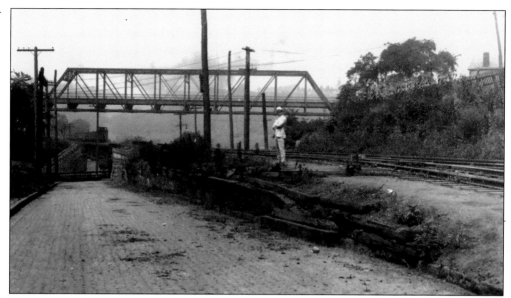

An unknown man, perhaps the photographer's assistant, stands on the railroad's retaining wall along Thompson Avenue. The White Bridge, a covered bridge built in 1876 that crossed Chartiers Creek at a lower elevation, stood near this location, as did a later suspension footbridge. In the background is the two-lane Windgap Bridge that spanned Chartiers Creek for 70 years from July 1914 to 1985. (P&LE Historical Society.)

The first St. Mary's Church was built near this site on Creek Road in 1855 for $800. The little brick church measured 20 feet by 40 feet and served the people for 27 years. There was also a school, rectory, and small cemetery. However, due to the repeated floods near the creek, the parish moved in 1886 to its second, temporary location on Thompson Avenue near the location of the present church. St Mary's Parish sold this property to Ulrich Hufnagel in 1924. (St. John of God Parish.)

Five

NEIGHBORHOOD VIEWS

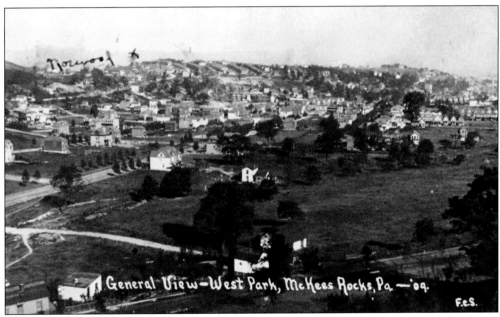

After it was incorporated in 1892, McKees Rocks quickly crowded its one square mile of land with hundreds of homes, businesses, and factories. There was no room to expand. However, Stowe Township, just beyond borough boundaries, was still mostly rural. That would all soon change. By 1900, the home building boom in Stowe Township had started with newspaper advertisements heralding the coming of new home lots in West Park, Norwood, and Herrington Hill.

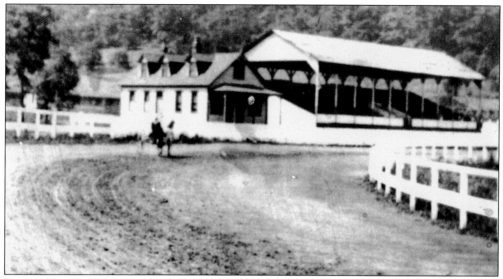

The McKees Rocks Driving Park thrilled the race-loving public from 1893 to 1900. The track got its start when Thomas and Frank Bryan, David Shaw, William Zinkhan, and Frank Dohrman, along with other local businessmen, purchased 30 acres of level land from Elizabeth Dohrman for $21,139.20 and built a well-equipped half-mile oval track, complete with a grandstand, stables, and fencing. According to a *Pittsburgh Commercial Gazette* article, the track was considered one of the best half-mile tracks in the country. With the new Brunot Island Track offering free Saturday matinees and superior quality racing, by 1900, fans had tired of spending half the afternoon just to reach the racetrack in Stowe Township. On October 19, 1900, the shareholders sold the track for $60,000 to the West End Land Company. The clubhouse still stands on the corner of Knox Street and Russellwood Avenue. (Above, Mazzotta's Market; below, Carnegie Library of Pittsburgh and John Makar.)

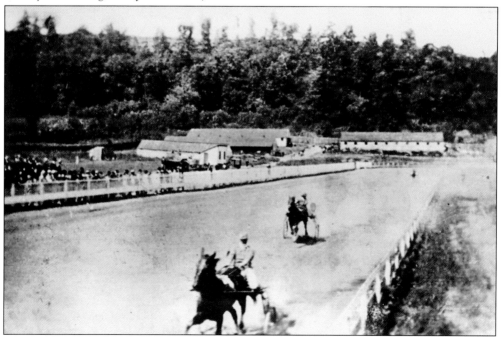

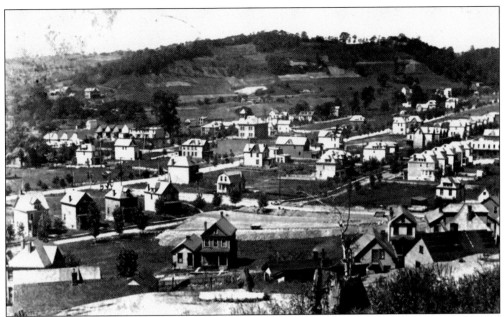

This wonderful c. 1903 photograph, taken from Norwood Place, overlooks a sparsely developed West Park. In the center of the photograph, land grading is being done as dirt fill is being added to raise and level the lots. West Park School is visible in the upper center of the image. Just beyond the school, the white fencing of the racetrack loop can still be seen. In the distance is Pine Hollow Road.

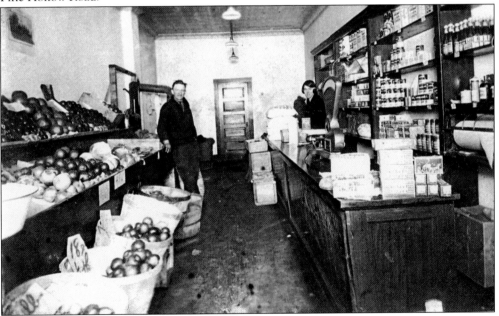

In this 1927 photograph, proprietors Victor and Marie Kasperski are seen inside their fruit market on Broadway in West Park. This store was typical of the many family-owned small stores in this Stowe Township business district. Unlike most shop owners who lived above their store, the Kasperski grocers lived in Kennedy Township, on Coraopolis Road. The couple raised six children. (Mary Lou Rote.)

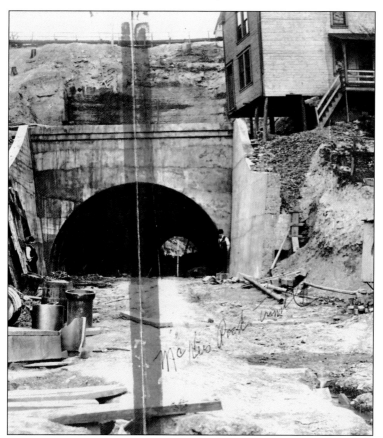

The West Park Tunnel is pictured in 1909. Talk of boring through Norwood Hill to build the West Park Tunnel started in 1907 when McKees Rocks was ambitiously raising hundreds of buildings and Chartiers Avenue to avoid flood damage. Developers believed the West Park Tunnel would fuel the growth of the borough by providing a quick portal between West Park and Island Avenue. Although the tunnel was completed in 1909 and cost more than $250,000, it was shut down and barricaded by 1930 due to a crumbling concrete ceiling.

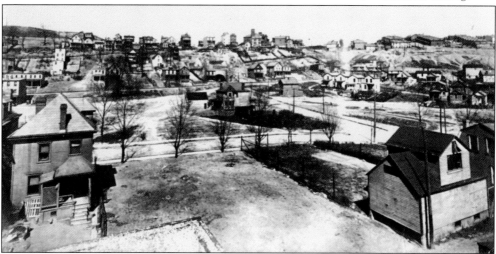

Woodward and Seventh Avenues intersect to the right of this 1930 photograph. Along the horizon, Norwood School and the neat rows of houses on Frazier, McKinnie, and Highland Avenues are visible. Follow Seventh Avenue to locate the West Park Tunnel. The tunnel is 432 feet long and 28 feet wide. Deterioration set in rather quickly. Stowe High School students used the barricaded tunnel as a shortcut in the 1930s despite the dangers. The repaired tunnel did not reopen until August 1941.

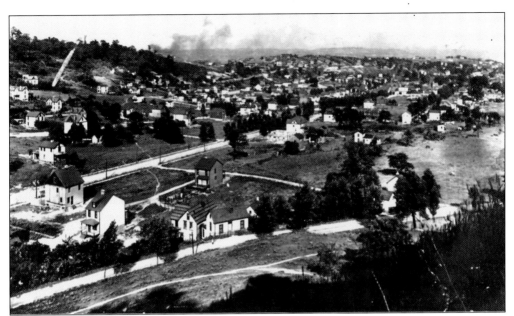

A full-page advertisement appeared in the *Pittsburg Dispatch* in June 1901, announcing the availability of the West Park lots. In just one year, 300 homes, seven miles of streets, and five and a half miles of sewers materialized. In this photograph of upper West Park, Broadway is approaching Kennedy Township and will soon intersect Pine Hollow Road, which is visible in the lower portion of this snapshot. (Sue Homer Bennardo.)

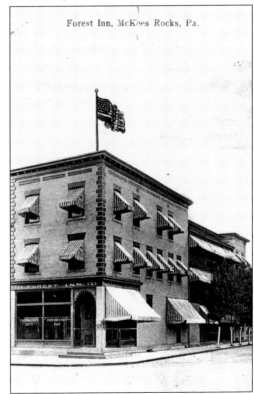

The Forest Inn, located at Broadway and Dohrman Street, is a landmark in West Park. It has been used as a hotel, refuge for flood victims, lunchroom for schoolchildren, and meeting place to celebrate Stowe Stallion victories. Frank and Della Gmeindl, who met as teenagers working at the Forest Inn, bought this old institution in 1946 and ran it for many years. It was famous for its turtle soup. (Tom Berilla.)

43

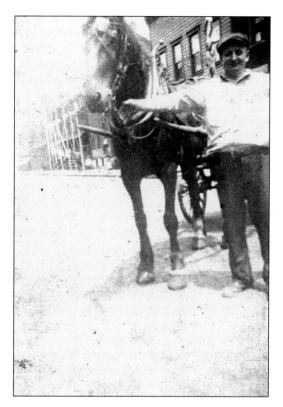

John Hopay Sr. is pictured in the 1920s with his horse-drawn wagon full of fruits and vegetables. Hucksters provided a valuable service in their neighborhoods by buying large quantities of fresh fruits and vegetables wholesale and then selling them in smaller quantities in their local neighborhood. Hopay and his son, John, would make early-morning treks from the Bottoms to the Strip District down congested West Carson Street. If a horse threw a shoe, it could be quickly repaired at the horse stable on Liberty Avenue. (John Hopay.)

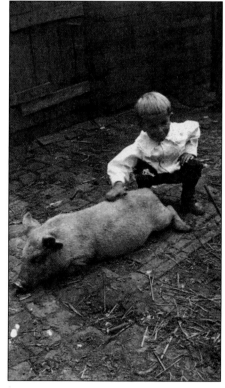

This endearing photograph of a young child petting a pig presents only half the story. Putting food on the table was a constant challenge. Women grew vegetables in any plot of ground readily available. Once or twice a year a family would buy a small pig, feeding it anything and everything until it grew large enough to slaughter. The young boy in this photograph is John Hopay, who started delivering homemade Best Yet potato chips at age 16 and grew his business into Hopay Distributors. (John Hopay.)

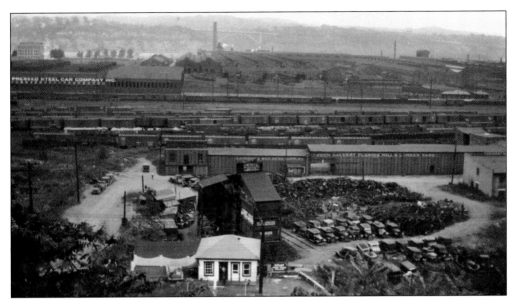

Businesses along the Ohio River were booming in the 1930s. This panoramic view from Island Avenue looking toward the Ohio River and Bellevue shows the 180-acre plant of the Pressed Steel Car Company (which employed over 5,500 workers at its peak), the John Calvert Lumber Company, and McKees Rocks Auto Wreckers. (Bill Vattimo.)

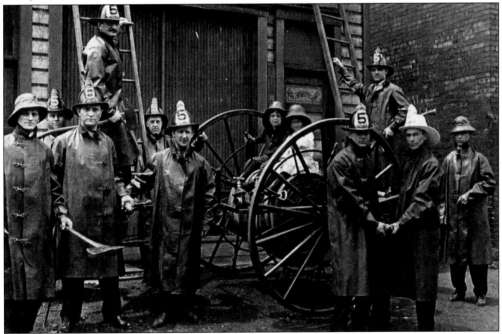

In 1905, when a fire destroyed the 372 Helen Street residence of G. F. Harrison, owner of the Union Dairy Company, funds were raised to build hose house No. 5 and purchase the handcart seen in the photograph. Pictured in front of the hose house on Helen Street are Andy Herrick, Tom Collin, Curtis Speck, Bill Duffy (captain), Johnnie Davis, Joe Yurkovitz (assistant chief), Frank Julius, David Simon, Arthur Butterfield, Howard Speck and his sister (on cart), and Joe Hoffman. (Dave Dietz.)

45

Rather than a gambling facility, as the name suggests, the Presston Casino served as a recreation center from 1914 to the late 1940s. Center Street led straight to the casino, which was located on Orchard Street.

Pictured here is the general office building of the Pressed Steel Car Company. In 1899, the Pressed Steel Car Company decided to build a large car manufacturing plant in Stowe Township. Charles T. Schoen invented the pressed steel car, revolutionizing railroad transportation. He established his first plant near Woods Run in Allegheny City and constructed the first all-steel hopper coal car for commercial purposes. The facility closed in 1949. The general office building was demolished in 1961.

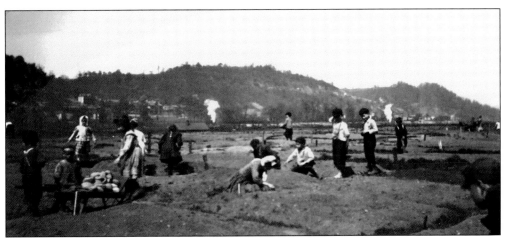

When the Pressed Steel Car Company opened shop in Stowe Township, it was necessary to provide housing for the workers and their families. Originally 240 houses were built. Later, in 1903, a large brick apartment house was added to the residential district. It contained 32 suites of three rooms each. These two 1910 photographs illustrate the self-sufficiency of Presston residents who continued farming in Presston. In the photograph above, Davis School can be seen on the far hill as a P&LE locomotive steams along in the background. In the photograph below, the "brickhouse," torn down in 1981, can be seen as well as a corner of the general office building.

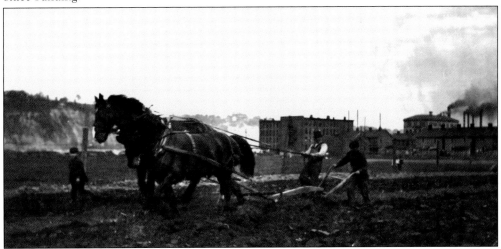

The Fidelity Land Company supervised the village of Presston, ensuring that all tenants received fair treatment and that houses were maintained in good condition. Additionally, it provided wooden sidewalks, planted trees in parks, and encouraged people to beautify their own landscaping by offering prizes annually for the best-kept yards. Activities were planned for various holidays, especially the Fourth of July, when the little village went all out with celebrations, parades, and picnics. The Presston footbridge and the "Dinky," the Schoenville shuttle, which served as the neighborhood trolley, can be seen. These historic photographs from the mid-1920s offer a charming glimpse of Americana at the beginning of the 20th century.

Harry Homer was the first of his family to become a Stowe Township policeman. In this 1920s photograph, he appears on his motorcycle in front of Jerry's Place, his brother's confectionery store in Pittock. Harry and his brother Steve (also known as Jerry) both belonged to Stowe's Hose Company No. 2. Officer Harry was 28 years old when he was killed by a passing motorist while leaving the police station on Island Avenue in 1924. (Sue Homer Bennardo.)

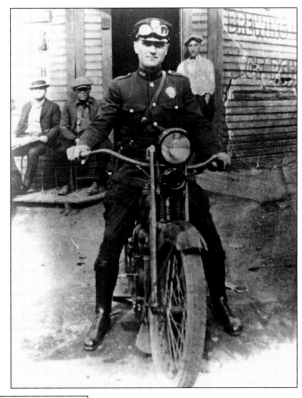

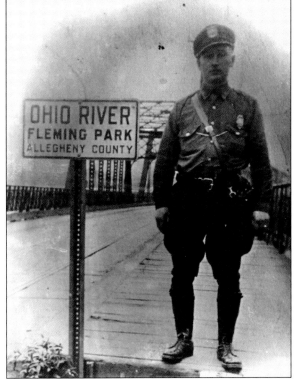

Three Homer brothers all served as Stowe patrolmen in the 1920s and 1930s, Steve, Max, and Harry. In this early-1930s photograph, Steve stands on the Fleming Park Bridge, which connects Stowe Township to Neville Island. Steve's son also became a Stowe policeman. Stephen Homer Jr. served as Stowe chief of police from 1973 to 1994 and belonged to the Stowe Police Department for 45 years. (Sue Homer Bennardo.)

Trap's Hotel, a Pittock landmark, was a three-story red brick building with a distinctive turret. It had 32 rooms, a dining room, ballroom, bar, and a stable in the back. Torn down in the early 1960s, Trap's Hotel demise allowed for progress and the widening of Neville Road, which runs from Route 51 to McCoy Road. Pat Trapuzzano bought the building, once used as a dairy store, in 1943. Before it was Trap's Hotel, it was known as the Yost Hotel. (Patrick Trapuzzano.)

Pat Trapuzzano, proprietor of Trap's Hotel, was friendly, outgoing, and sociable. Some may remember his pet monkey that sat on his shoulder in the bar. Whether campaigning for a favorite political candidate, like Bill Scranton for governor in 1962, volunteering with the fire department, or riding his horse, Silver, down the streets of Pittock like the Lone Ranger, he lived life with gusto. (Aaron Trapuzzano.)

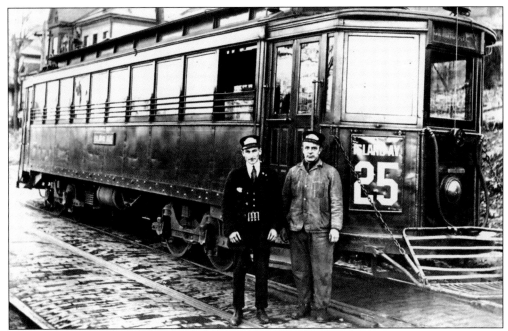

The Pittsburgh and West End Passenger Railway Company began streetcar service to McKees Rocks in 1889. This photograph from the 1920s features the Island Avenue No. 25, which eventually ran down Island Avenue to Fleming Park and looped back. This style of trolley was phased out for the new streamliners known as Presidents Conference Committee (PCC) cars. (Pennsylvania Trolley Museum and John Makar.)

Nelson J. Angell was born on May 30, 1877, and died in 1914. Employed as an engineer, he and his wife, Josephine, whom he married in 1903, made their home at 1122 Thompson Avenue. Nelson served as a member of the volunteer McKees Rocks Fire Department. (Dan and Terri Angell.)

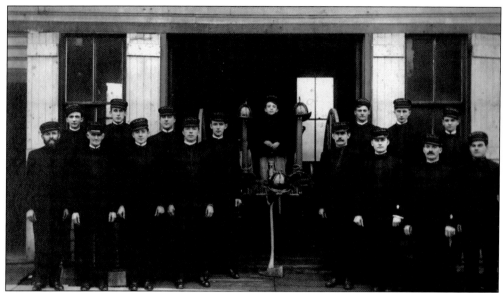

This is a 1908 photograph of McKees Rocks Hose Company No. 3, at Singer and Chartiers Avenues. The volunteer firemen pictured are, from left to right, (first row) unidentified, ? Hogan, William Frank, Fred Ehrhardt, Frank Wilde, Michael Nauman, Otto Zange, Ben Ehrhardt, and unidentified; (second row) John Ries, "Skip" McAleer, unidentified, Lawrence "Midge" Ehrhardt (on cart), ? Heinauer, William Caughey, and unidentified. (McKees Rocks Fire Department.)

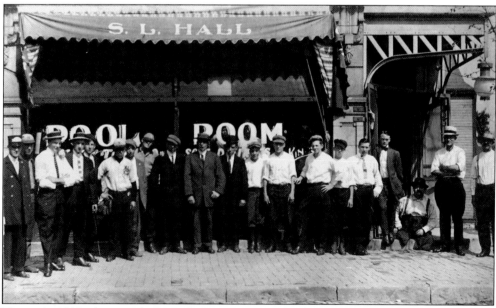

This early-1900s photograph shows the longtime 900 Island Avenue landmark, Hall's Café. Back then, Louis Hall ran the first floor of the 15-room, three-story, redbrick hotel as a poolroom. In a story related to Rocky Phillips of the *Suburban Gazette* in 2001, the late Herby Hall recalled, "As a poolroom in the early 1900s, it was something right out of film noir: Louis Hall was legless and got around on a roller board, even managing to rack balls from his short perch." (Studio Ten Photography.)

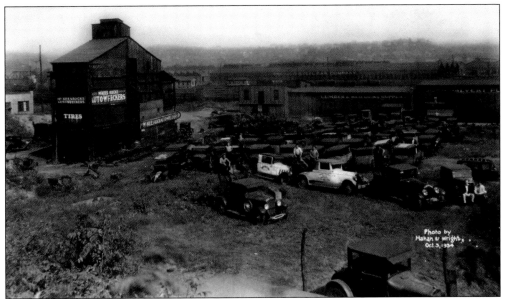

This 1934 photograph showcases Milly's McKees Rocks Auto Wreckers, owned by Emilio (Milly) Vattimo. Milly started his automobile wrecking business in 1929 on Island Avenue near the Presston Footbridge and rented the grounds from John Calvert Lumber Company. His enterprises expanded to used car sales and a moving business. The office for the business was located 709 Yunker Street. Milly later sold the office building to Linder's Furniture. (Bill Vattimo.)

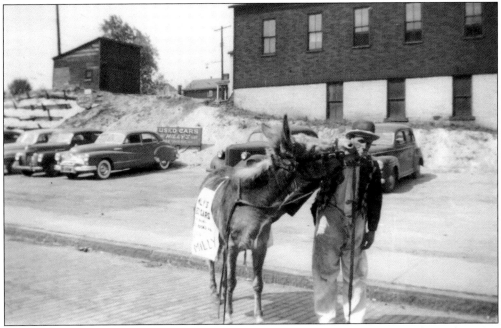

The clown and his "moving billboard" donkey were often seen marching in parades in the 1930s in Stowe or McKees Rocks to advertise Milly's Used Cars. Milly's Used Cars often showed a sense of humor in advertisements, using spelling variations of McKees Rocks (Mikizrakzy or Michis Rochis) on everything from pocketknives to pot holders. (Bill Vattimo.)

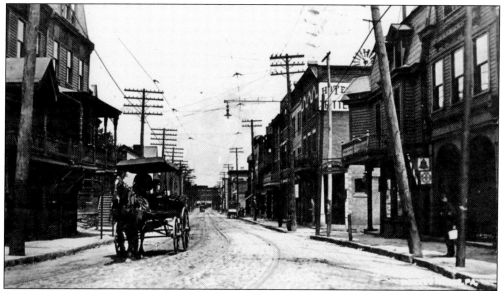

This early-1900s photograph shows a horse and buggy trotting down Island Avenue toward Chartiers Avenue. Stretching from the Fleming Park Bridge in Stowe Township to Chartiers Avenue in McKees Rocks, a distance of a little over two miles, Island Avenue was like a city in itself. This heavily traveled thoroughfare divided the industrial town from the business and residential areas.

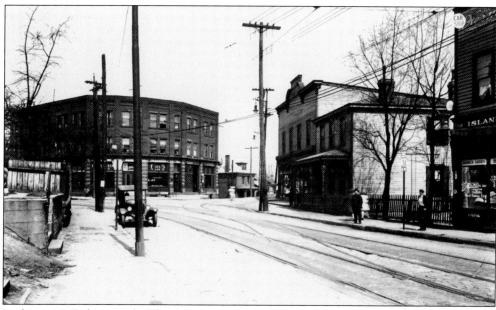

In this c. 1915 photograph, Island Avenue is leading to the O'Donovan Building. Reminiscent of the entrance to an old-style baseball park, this large, multifunctional building housed a variety of shops on the first floor with apartments and offices on the upper floors. Named after Michael C. O'Donovan, an Irish immigrant who worked as a railroad telegrapher before becoming a successful merchant, the O'Donovan Building was located near the Blaine School and the O'Donovan Bridge. It was demolished in 1930 for the McKees Rocks Bridge project.

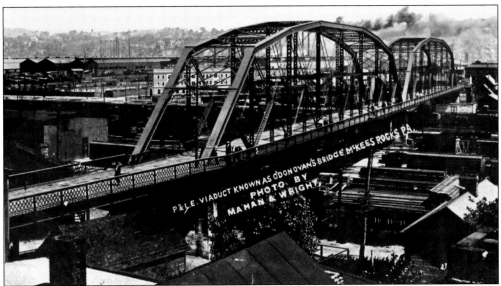

The P&LE Company built the O'Donovan Bridge in 1904 to eliminate the dangerous grade crossing over the railroad tracks from Island Avenue to the Bottoms. The P&LE agreed to build the bridge, and the borough agreed to maintain it. In August 1909, two state police officers were fatally attacked by a mob at O'Donovan Bridge during the Pressed Steel Car strike riots. The McKees Rocks Bridge, built in 1931, replaced the O'Donovan Bridge. (Georgine Verlinich.)

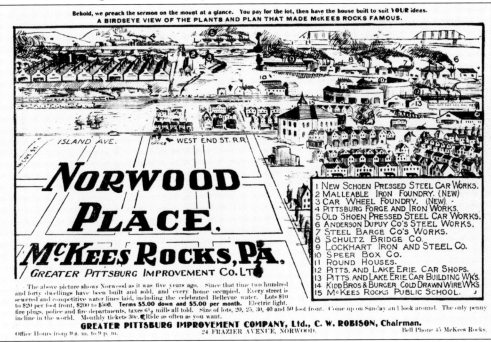

Norwood Place in Stowe Township was marketed by C. W. Robison of the Greater Pittsburg Improvement Company in 1899. A booklet published by the Gazette Printing Company advertised four-, five-, and six-room houses having complete bathrooms along with gas, city water, cemented basements, and sewers. Perched on a hill reminiscent of regions in Italy, Norwood Place offered homeowners an escape from the dirt and smoke of the steel mills below.

These are two views of the Ohio Valley General Hospital taken in the 1920s when it was located in Norwood Place. The photograph above shows a distant, front view of the hospital, high on the hill. The photograph below shows the back of the hospital, on the site of the current Mother of Sorrows Church. When Norwood Place began selling lots in 1899, Dr. S. M. Black proposed building a new hospital there, above the smoke and dirt of Island Avenue. The three-story McKees Rocks General Hospital was completed in 1900 and had 30 beds. It was accessible via the Norwood Incline or McCoy Road. In 1906, it was renamed the Ohio Valley General Hospital. A new wing was added in 1909 along with bassinets and service facilities. By 1930, the hospital, with 60 beds, was overcrowded and in need of repair. It continued to be used until the new facility opened in Kennedy Township in 1949.

The Norwood Incline was built in 1901 by Charles Wesley Robison. Robison's company was selling home lots in the Norwood Plan and wanted to facilitate access to the Norwood hilltop. Patrons could hop on the incline, at no charge, from the lower station, located at 907½ Island Avenue, near Adrian Street or the upper station, situated on Desiderio Avenue between McKinnie Avenue and Highland Avenue. Fare went up to a penny in 1903 during peak hours, giving it the nickname "Penny Incline." The little yellow cars were built on a three-rail automatic turnout system. A curved bypass allowed the cars to switch out quickly and pass each other. With the popularity of the trolley and automobile, the incline lost customers. Ongoing maintenance costs finally forced the Norwood Incline to close in 1923. Wooden steps, and later concrete steps, were built on the incline's right-of-way in 1930. (Below, Dick Naughton.)

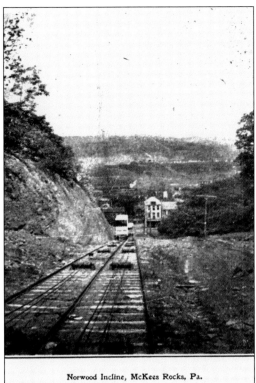

Norwood Incline, McKees Rocks, Pa.
Gazette Pub. Co., McKees Rocks, Pa.

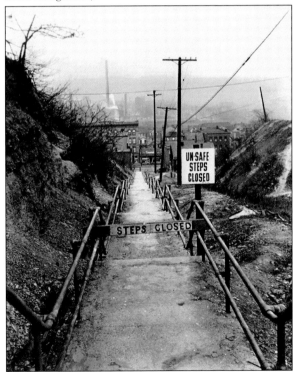

UN-SAFE STEPS CLOSED

STEPS CLOSED

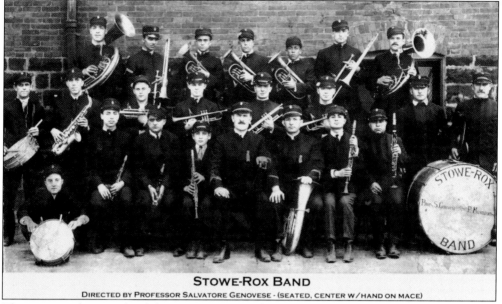

STOWE-ROX BAND

DIRECTED BY PROFESSOR SALVATORE GENOVESE · (SEATED, CENTER W/HAND ON MACE)

This vintage photograph of the Stowe-Rox Band under the direction of Salvatore Genovese was taken in front of the Norwood School. Professor Genovese, as he was called, was a lifelong musician. He immigrated to the United States in 1899 from Calabria, Italy, and lived in New York until 1906 when he moved to Norwood and opened a barbershop at 605 McCoy Road. This was one of the first times that the expression "Stowe-Rox" was used. (Studio Ten Photography.)

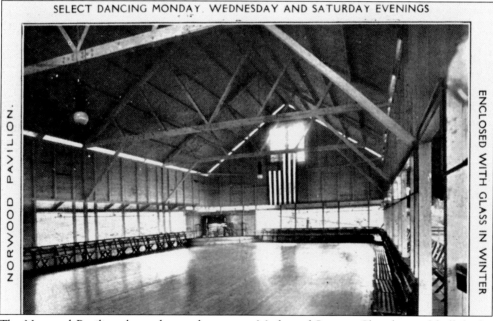

SELECT DANCING MONDAY WEDNESDAY AND SATURDAY EVENINGS

NORWOOD PAVILION.

ENCLOSED WITH GLASS IN WINTER

The Norwood Pavilion, located near the current Mother of Sorrows Church social hall, had a sweeping, panoramic view of the Ohio River valley. It was easily accessible via the Norwood Incline and was the site of many dances. In the winter, the pavilion was enclosed in glass to enable year-round functions, such as New Year's Eve celebrations. In 1911, the West End Lyceum held its Memorial Day dance in the Norwood Pavilion. It came down during a severe windstorm in 1932.

Six

TOWN ON THE MOVE

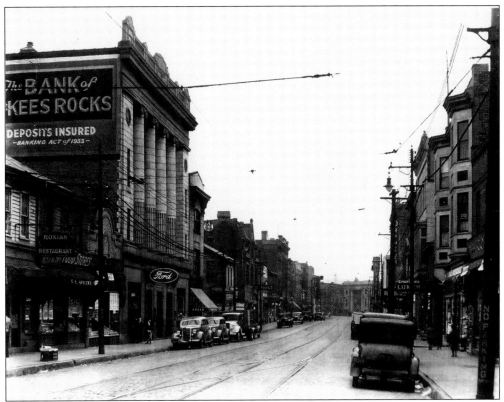

This 1935 photograph highlights the many retail businesses on Chartiers Avenue from the 600 block near the PC&Y crossing east to the 300 block, where the road bent to the left in front of the First National Bank of McKees Rocks. McKees Rocks had restaurants, grocery stores, car dealerships, bars, social clubs, movie theaters, and more. Trolleys were constantly clanking down Chartiers or Island Avenues at all hours. Crowds of people were always out walking to work, dances, theaters, and sporting events. Everyone had somewhere to go. (Nancy Jacobs.)

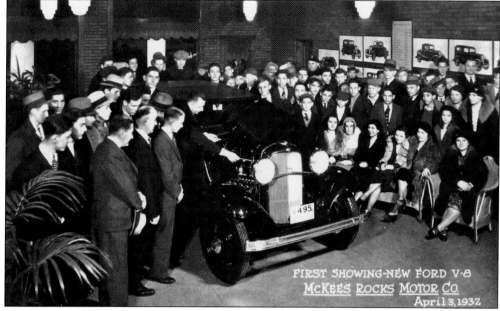

FIRST SHOWING-NEW FORD V-8
McKEES ROCKS MOTOR CO.
April 3, 1932

This photograph, taken by Mahan and Wright, marks the 1932 unveiling of the new Ford V-8 at Sam Werlinich's Ford dealership located on the first floor of the Bank of McKees Rocks building on Chartiers Avenue. The 1932 Ford V-8 had a 65-horsepower engine and a style to appeal to every driver. Prices ranged from $460 for the roadster, $490 for the coupe, and $650 for the convertible sedan. Sam Werlinich is second from the left in the first row of this photograph. (Nancy Jacobs.)

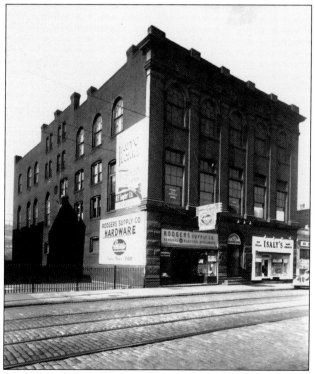

Built in 1899 for $20,000, Fraternal Hall stood at 525 Chartiers Avenue. This grand, old building was home to many enterprises. The old Liberty Theatre operated here until it was replaced in 1929 with Books Shoes, managed by Frank Anzenberger. Books Shoes was replaced by the Rodgers Supply Company. Isaly's operated here from 1934 to 1971. Fraternal Hall hosted many banquets, celebrations, and ceremonies through the years. (Vicki Batcha.)

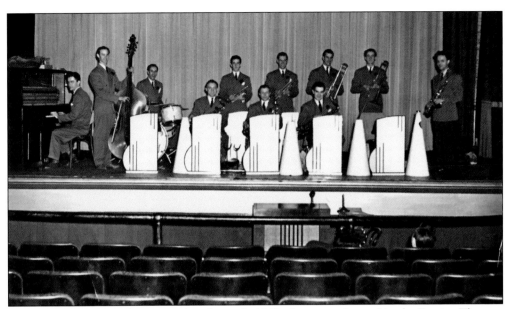

The Tal Williams Band is pictured in the early 1940s during a rehearsal in the Roxian Theatre. Band members include Tony Gargaro and Walter Vrusk, both on trumpet. (Lita Gargaro Fuze.)

The showplace of McKees Rocks, the Roxian on Chartiers Avenue, built in the late 1920s, was always more than just a movie theater. It featured big bands in the 1930s and 1940s, boxing matches in the 1950s, and personal appearances by celebrities like Tex Ritter. It even had a bowling alley in the basement where Fred "Tex" Williams made *Ripley's Believe It Or Not*, when he bowled two consecutive perfect 300 games on alleys 9 and 10 in 1934. In later years, it functioned as a lounge, nightclub, and banquet hall. (Author's collection.)

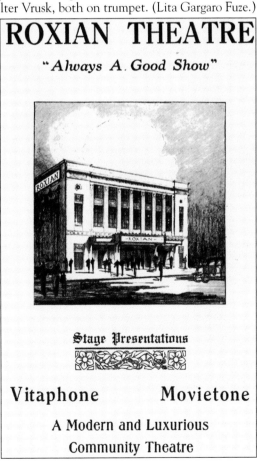

ROXIAN THEATRE

"Always A Good Show"

Stage Presentations

Vitaphone Movietone

A Modern and Luxurious
Community Theatre

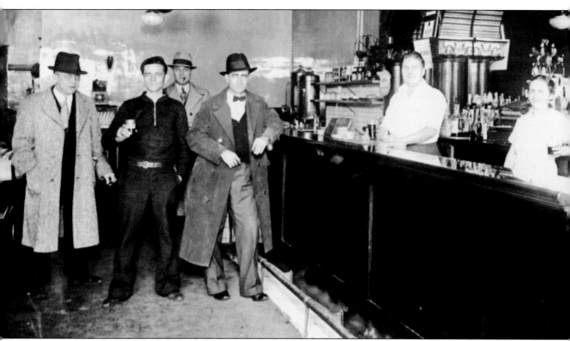

Some suggest the man smoking a cigar in this photograph is the famous gangster Al Capone. There was a time when everyone in McKees Rocks had an Al Capone story. There were rumors of a shoot-out in West Park, an eyewitness account of a local doctor providing him with medical treatment, and Pittsburgh newspapers reporting that, in March 1930, Capone spent two days here with Italian political leader and racketeer Albert Cerceo, after being released from Eastern Penitentiary. Although Cerceo admitted meeting Capone in 1925 in Chicago, he denied the 1930 Capone visit in a newspaper report, calling it "a joke." At least two original prints of this photograph exist. One belongs to the Mosimann family, who owned the Enterprise Hotel where it was taken. John Mosimann and his mother, Anna, are seen tending the bar. Anna Mosimann often spoke of knowing Al Capone. The other print belongs to the descendants of Frank Frisch, the man holding the glass. Frisch told his family this was Capone in the photograph. (Betty Mosimann Trapuzzano.)

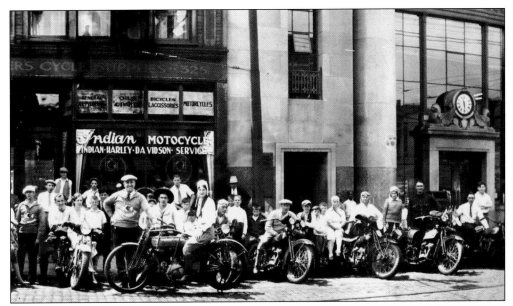

Mahan and Wright made this photograph of the McKees Rocks Motor Cycle Club on June 14, 1931, before the start of the annual Gypsy Tour, a favorite pastime of riding clubs. Over two dozen cycle enthusiasts, along with family and friends, proudly gathered with their cycles in front of Baker's Cycle Shop at 325 Chartiers Avenue for this photograph before heading out to the popular Idora Amusement Park in Youngstown, Ohio. (Judy Salera.)

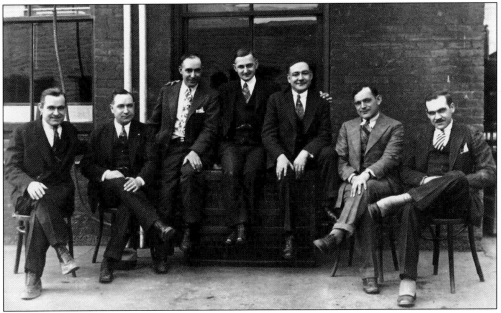

This 1930 photograph shows the seven Baker brothers, Lou, Mike, Nick (burgess of McKees Rocks, 1938–1942), Frank, Sylvester, Billy, and Herman. At its peak in the 1920s and 1930s, the Seven Baker Brothers operation had more than 30 employees, 100 trucks, and originated the brand name of Wonder Bread. During World War II, business declined due to food rationing and a lack of skilled workers. By the end of the war, the Seven Baker Brothers filed for bankruptcy. (Jim and Pat Baker.)

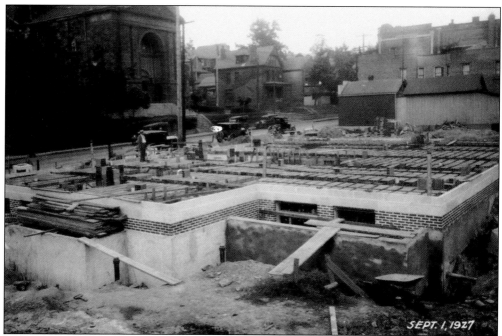

This September 1927 photograph shows the early stages of construction of the current McKees Rocks Post Office at 807 Chartiers Avenue. Excavation was started in June 1927 and completed in May 1928. The first post office in McKees Rocks was established in 1861 in Bryan's Tavern, the present site of Mann's Hotel. Mail was carried from Pittsburgh by stagecoach, then later by the railroad. The second site was in the post office building at 708 Chartiers Avenue, next to the Commonwealth Hotel. (McKees Rocks Post Office.)

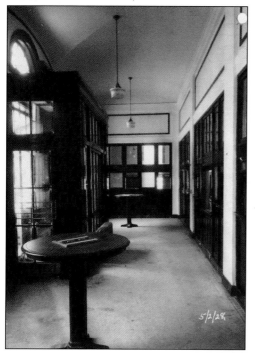

This is an interior view of the new McKees Rocks Post Office at 807 Chartiers Avenue in 1928. The art deco interior of the newly completed post office was bright and open. (McKees Rocks Post Office.)

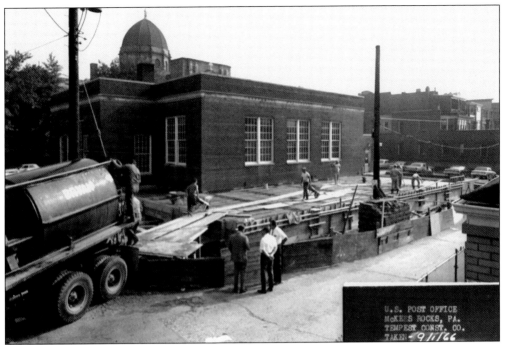

This photograph was taken in September 1966, when a new addition was built for the post office. Local supplier Frank Bryan Inc. poured the cement foundation. This company, founded by Frank Bryan, erected its first concrete plant in 1920 in McKees Rocks, adjacent to a stone quarry it operated next to the Indian Mound. Charles A. Knoll was postmaster of McKees Rocks at this time. (McKees Rocks Post Office.)

This is a 1932 photograph of the Jesse Apartments and an industrial section of the Bottoms showing long views down Graham Street and George Street. The steel mill appears to the left of the photograph. Riots broke out at this site during the 1909 Pressed Steel Car strike.

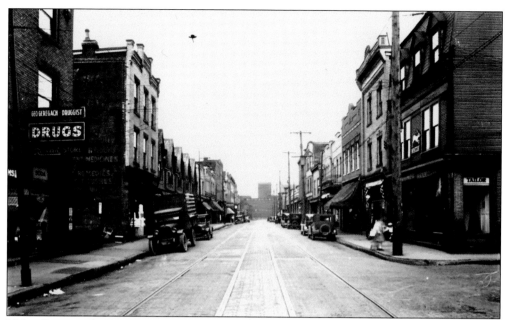

Helen Street in the Bottoms is pictured in 1929. The many mills and factories enabled businesses like Geregach Drug Store (left) to be successful.

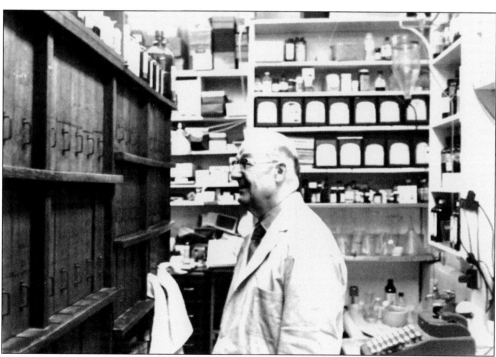

This is a 1960s photograph of druggist George Geregach tending shop in his pharmacy on Helen Street. Many folks have fond memories of seeing a movie at the Regent Theater, located at the corner of Helen and George Streets, and then stopping by Geregach Drug Store for a banana split at the soda bar. (Joan Geregach.)

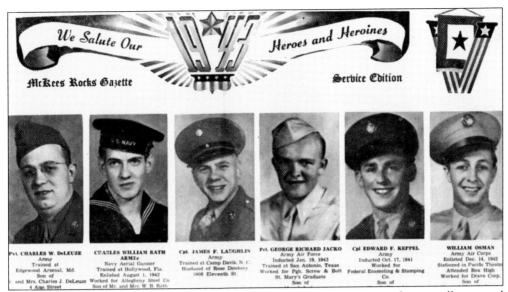

Pvt. CHARLES W. DeLEUZE	CHARLES WILLIAM RATH	Cpl. JAMES F. LAUGHLIN	Pvt. GEORGE RICHARD JACKO	Cpl EDWARD F. KEPPEL	WILLIAM OSMAN
Army	ARM3c	Army	Army Air Force	Army	Army Air Corps
Trained at	Navy Aerial Gunner	Trained at Camp Davis, N. C.	Inducted Jan. 19, 1943	Inducted Oct. 17, 1941	Enlisted Dec. 14, 1942
Edgewood Arsenal, Md.	Trained at Hollywood, Fla.	Husband of Rose Dendony	Trained at San Antonio, Texas	Worked for	Stationed in Pacific Theater
Son of	Enlisted August 1, 1942	1003 Eleventh St.	Worked for Pgh. Screw & Bolt	Federal Enameling & Stamping	Attended Rox High
r. and Mrs. Charles J. DeLeuze	Worked for Allegheny Steel Co.		St. Mary's Graduate	Co.	Worked for Dravo Corp.
4 Ann Street	Son of Mr. and Mrs. W. B. Rath		Son of	Son of	Son of

In January 1943, the *McKees Rocks Gazette* announced plans to print a tribute to all men and women in the armed forces. This edition contained over 2,000 photographs and ran 80 pages and 10 sections. For weeks, the *McKees Rocks Gazette* encouraged families to send in a photograph of their servicemen or servicewomen to be used in this special service edition. The result was a phenomenal success. The newspaper printed over 10,000 copies of this keepsake tribute on December 30, 1943. (Suburban Gazette.)

This is a 1940s wartime photograph of Joseph Verlinich with his sons Cpl. John Verlinich and Pvt. George Verlinich of 310 Catherine Street. The 300 block of Catherine Street was featured in an article in the *Pittsburgh Post Gazette* when a survey discovered it had the most servicemen for the number of houses in any block of homes in Allegheny County. There were 20 men serving in the armed forces from 12 houses on the 300 block of Catherine Street in the Bottoms. (Georgine Verlinich.)

Pictured here is the Kanai Funeral Home, built in 1925 and located at the corner of Helen and Ella Streets. The chapel was the first of its kind in the vicinity. Kanai's handled the funeral in the sensationalized murder of Martha Westwood in July 1935. More than 2,000 men, women, and children passed before her coffin in the funeral home. Justice of the peace James J. Westwood was charged with shooting his wife, Martha, while she was sleeping in their Ella Street apartment. (Edward Kanai.)

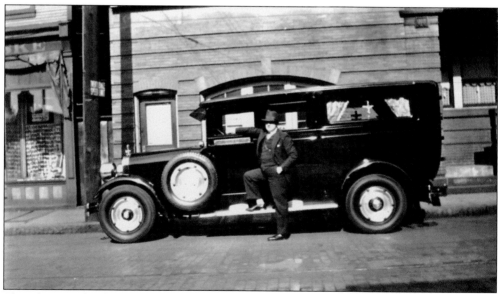

This photograph taken in the 1930s is of Peter Kanai standing next to a hearse in front of his 300 Helen Street location. With a career in the funeral business that began in 1915 in McKees Rocks, he owned and operated four funeral homes in the Pittsburgh area: Greenfield, the North Side, McKees Rocks, and Stowe Township. (Edward Kanai.)

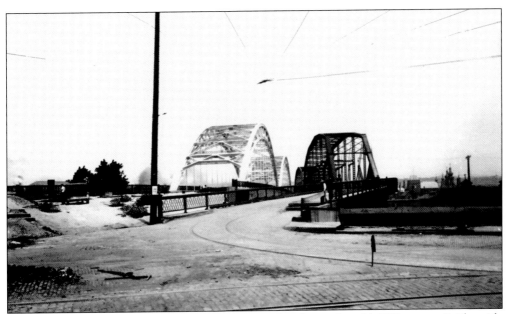

This interesting photograph, taken on May 2, 1931, shows the old O'Donovan Bridge side by side with the newly constructed McKees Rocks Bridge. The O'Donovan Bridge served the region from 1904 to 1931. Hundreds of men walked across it daily on their way to work at the Pressed Steel Car Company, the Schoen Steel Wheel Works, and the many other industries in the Bottoms.

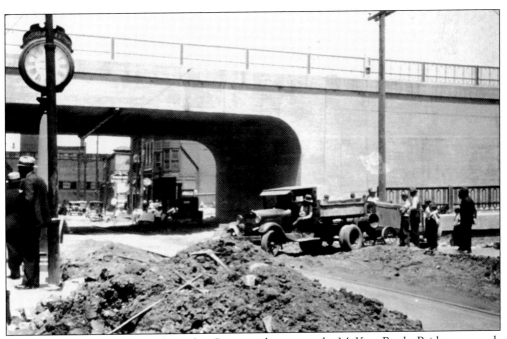

This 1931 photograph shows the Helen Street underpass on the McKees Rocks Bridge approach that passes over a commercial and residential section as well as more industrial and railroad areas. Also work is underway in building the concrete ramp leading off Helen Street onto the bridge.

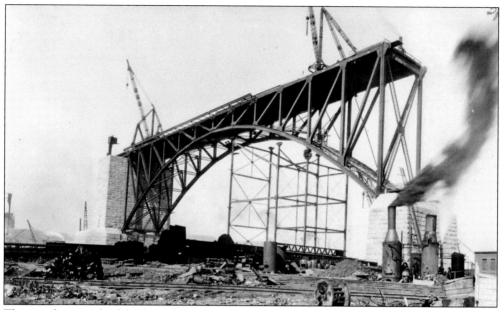

This is a photograph of the first section of steel erected on the north side of McKees Rocks Bridge, looking south, on September 10, 1930. With the completion of the McKees Rocks Bridge, the borough was easily accessible from the North Hills. Before 1931, travelers had to use the Point Bridge or Sewickley Bridge to cross the Ohio River. (Vicki Batcha.)

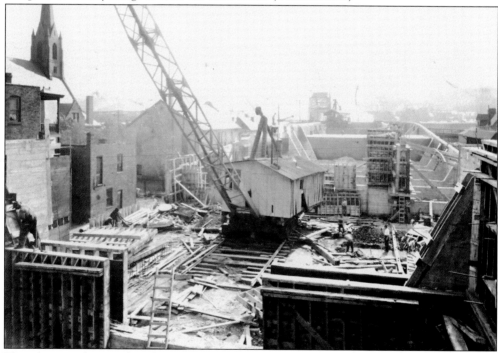

This photograph was taken during an early phase of the bridge construction in 1931. It shows heavy equipment on Munson Avenue, next to St. Mark Church. This engineering project, although disruptive to some families in the Bottoms, delighted the children because it gave them mountains of sand to climb.

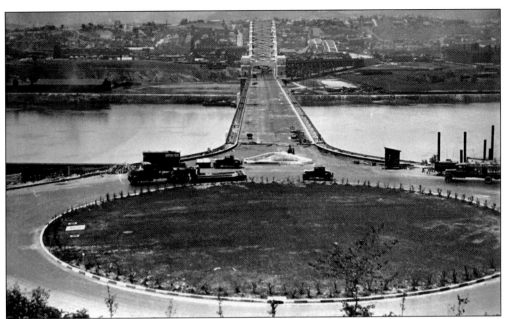

The McKees Rocks Bridge had a traffic circle with a circumference of 150 feet, as seen in this photograph taken on June 11, 1931. The circle was infamous for slowing down boulevard traffic. It was suspected to be one of the city's most dangerous intersections. However, a 1950 study showed that 15 Pittsburgh intersections were more dangerous. The circle was removed in May 1957 and replaced with traffic signals.

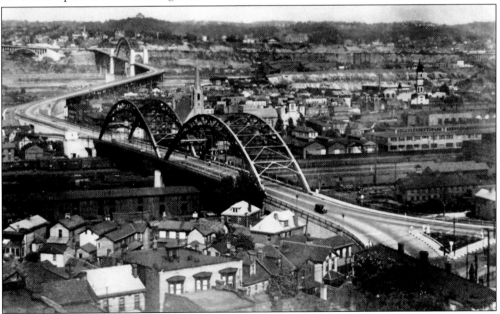

As early as 1913, there was talk that Allegheny County would construct a bridge from Woods Run to McKees Rocks. Yet it was not until 1931 that Allegheny County finally built the McKees Rocks Bridge for $7 million. The bridge, consisting of 12,000 tons of steel, stretches 5,900 feet from Island Avenue to Ohio River Boulevard. The McKees Rocks Bridge was listed in the National Register of Historic Places in 1988.

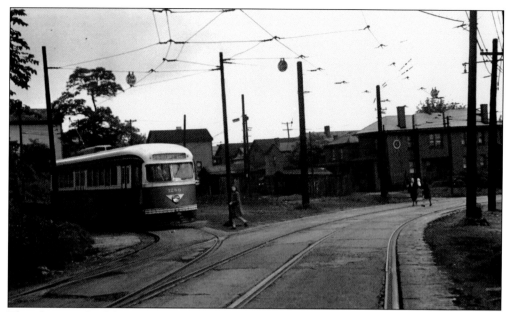

This photograph of the No. 25 Island Avenue trolley exiting the famous Fleming Park Loop was taken on July 19, 1951. The loop was track that curved around in a large semicircle, enabling the Pittsburgh Railways trolley to turn around and head back into McKees Rocks and downtown Pittsburgh. The loop was installed in 1941.

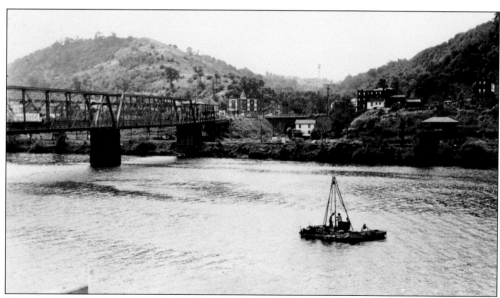

This is a photograph taken in 1951 of the 807-foot-long Fleming Park Bridge. The bridge carries two lanes of median-divided traffic over the P&LE tracks and the back channel of the Ohio River between Stowe Township and Neville Island. Trap's Hotel is visible in the background.

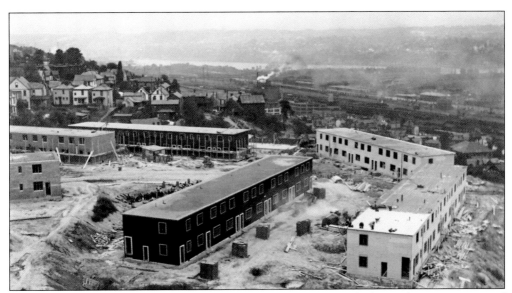

Taken in 1941 from the smokestack on the site, this photograph shows the construction of Allegheny County Housing Authority's first public housing project. The McKees Rocks Terrace was built for $1.3 million and opened in the spring of 1941. It included 27 brick and frame buildings and a total of 288 units. The 23-acre property was previously owned by the Meyer family who had farmed here for 85 years. The community of Meyer's Ridge now sits on this location.

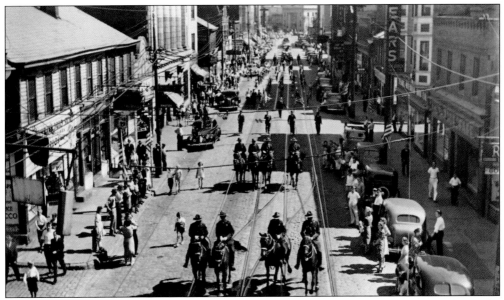

This September 1940 photograph shows the parade on Chartiers Avenue marking the cornerstone ceremony on the McKees Rocks Terrace. Marching bands, Boy Scout troops, fraternal organizations, and county, borough, and housing officials all marched behind the grand marshal, Bernard McDermott. Judge Michael A. Musmanno delivered the address, Rev. Howard Laffery of St. Francis de Sales Church gave the benediction, city councilman Edward J. Leonard placed the cornerstone, and Rev. Lloyd E. Headley of McKees Rocks Methodist Church delivered the invocation.

This is a 1950 photograph of William B. Zinkhan (center), son of the first burgess of McKees Rocks, with sons Bob (left) and Jennings (right) in the office of the Zinkhan Beer Distributing Company at 122 Chartiers Avenue. Zinkhan was also an architect and contractor who built homes on Zinkhan Street. In the 1960s, when his widow, Marion Zinkhan, visited McKees Rocks and saw that the new street sign attributed to her husband was misspelled, she marched into the mayor's office and demanded it be corrected. It is still Zinkham Street. (Marion Zinkhan Maniet.)

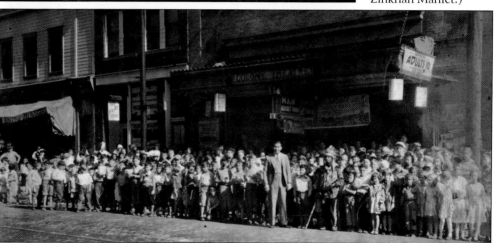

Last of the Mohicans, starring Harry Carey as Hawkeye, debuted in 1932. It was a serialized film of 12 episodes, each lasting 20 minutes. Every week a new episode was presented as a Saturday afternoon "kiddie" matinee along with lots of cartoons and newsreels. Each episode had a suspenseful cliffhanger, tempting young fans to return week after week. Theaters would actively promote the serialized movies with gimmicks. In this 1932 photograph, children pose with Chief Rainbow and the theater manager outside the Colony Theater at 720 Broadway in West Park. (Terri Angell.)

Seven

RISING WATERS

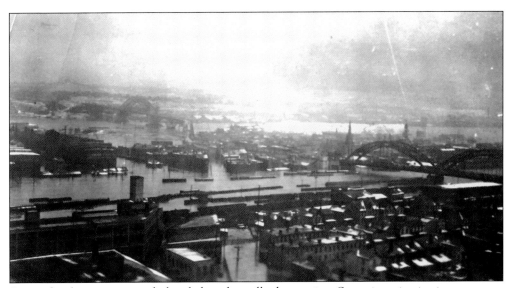

Spring floods were expected, dreaded, and usually destructive. Sometimes institutions gave up, like St. Mary's Church, which abandoned its Creek Road location in 1886 for higher ground. Sometimes business owners fought back, as in 1907, when they paid architects and engineers to raise the street level of Chartiers Avenue and elevate hundreds of massive buildings eight feet. Yet inevitably, the floods came. None was more destructive than the flood of 1936. (Jan Condeluci Uhler.)

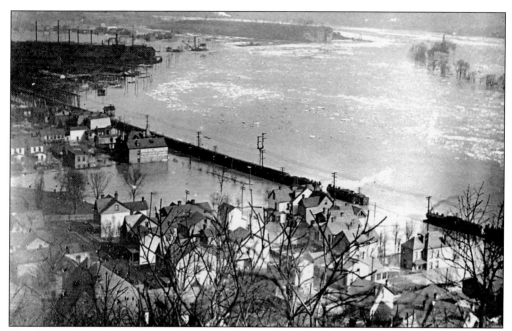

The flood of March 1902 crested at 32.4 feet. Mills and factories closed temporarily, putting 70,000 laborers out of work. At the top center of this photograph, the rocks underneath the Indian Mound are visible. Only a few trees on nearby Brunot Island are above water. West Carson Street and Esplen and lower McKees Rocks are mostly submerged. (Pennsylvania Trolley Museum Collection and John Makar.)

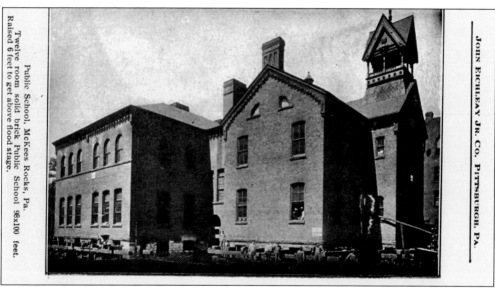

Public School, McKees Rocks, Pa.
Twelve room solid brick Public School 98x100 feet.
Raised 6 feet to get above flood stage.

JOHN EICHLEAY JR. CO., PITTSBURGH, PA.

Each year businessmen lost an estimated $150,000 due to spring floods. The devastating 1907 flood galvanized the borough to enact a Herculean plan to raise the level of Chartiers Avenue above the 35-foot flood stage level. All the buildings along a half-mile stretch of Chartiers Avenue and some side streets were jacked up and raised. Not since the historic raising of Chicago in the mid-1800s had such an ambitious engineering goal been accomplished.

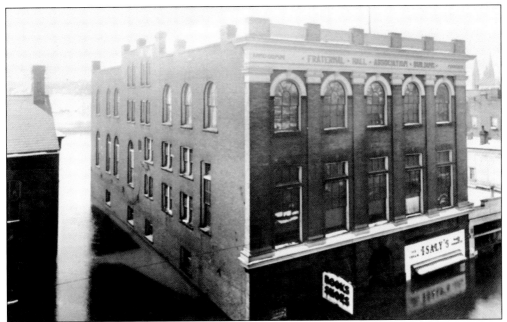

In 1907, more than 150 men, using 400 jacks, raised Fraternal Hall eight feet. The John Eichleay Jr. Company did the raising of the buildings, Booth and Flinn Company did the street work, and Pittsburgh Railways Company reset the trolley tracks. The total cost of the project was $450,000. This photograph shows Fraternal Hall on March 18, 1936, after the rivers crested at Pittsburgh at 46 feet. (Martin Savalchak.)

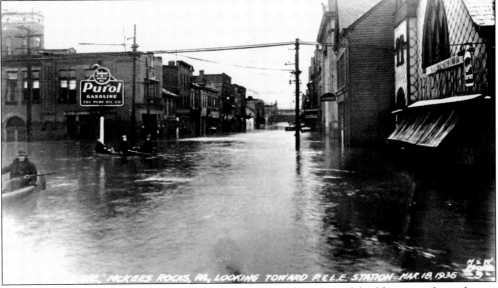

Visible in this 1936 photograph on the left is the old municipal building; on the right are the real estate office of F. J. Grogan and the Hupmobile dealership (previously the Calvary Lutheran Church). These buildings on lower Chartiers Avenue were all raised eight feet in 1907 to withstand a 35-foot flood stage level. Although this engineering improvement was effective for more than two decades, it did little to prevent the raging waters when the flood crested at 46 feet in 1936. (Martin Savalchak.)

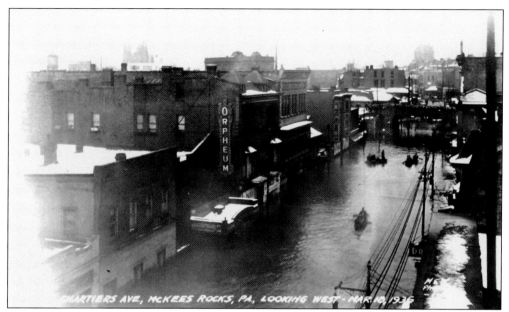

Police and volunteers scouted flooded streets in boats to help stranded residents. Electric power was out; water was cut off, as were gas lines; and most of the borough was left without heat. Crowds stood shoulder to shoulder on the PC&Y crossing bridge staring in disbelief at the flooded business district. In this photograph, rowboats, not trolleys, are navigating down Chartiers Avenue near the Orpheum Theater. (Martin Savalchak.)

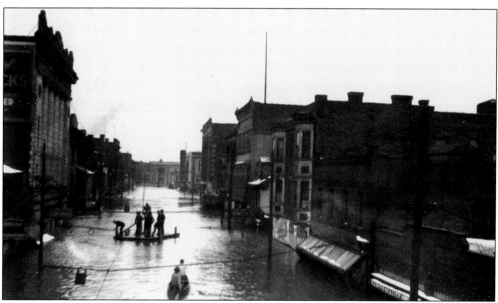

Looking more like a scene out of *Huckleberry Finn*, complete with river raft, this unbelievable view of Chartiers Avenue was taken on March 19, 1936. According to borough reports to the federal government, the flood covered 40 percent of the town and damaged 1,200 homes, 326 retail stores, and 15 manufacturing plants. (Dorothy Kelly.)

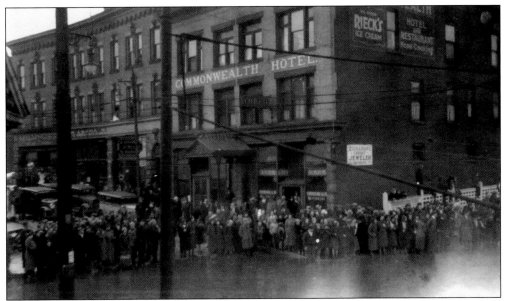

On March 16, 1936, the Allegheny and Monongahela Rivers were already overflowing their banks due to rapidly melting snow and ice. Heavy rains overnight caused the waters to rise quickly, and on March 18, St. Patrick's Day, the rising waters soon inundated the Bottoms, Presston, and Chartiers Avenue. In this photograph, stunned crowds gather in front of the Commonwealth Hotel to observe the scene. (Dorothy Kelly.)

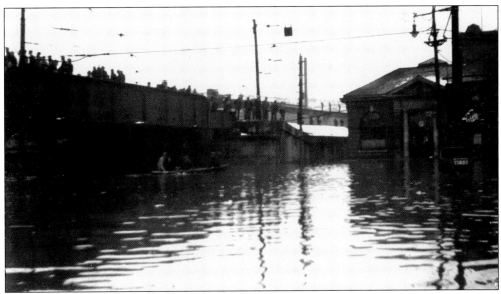

This photograph shows a flooded Chartiers Trust Company. For two weeks following the flood, the militia was housed in schools; teachers volunteered for relief work. Students did not return to school until April 6, and grade schools only held half-day sessions. Wilson and McKee Schools remained closed; those students attended Ellsworth, Hamilton, or Blaine for afternoon sessions. The school year was not extended, and both Easter vacation and the senior class play were cancelled.

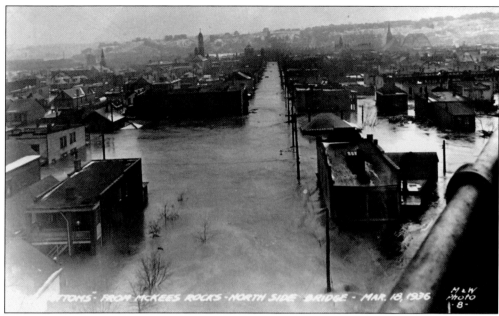

These two photographs show the total devastation the flood inflicted on the Bottoms. Hundreds of persons and 800 families were awaiting rescuers. More than a dozen fire companies from neighboring communities were working to bring victims to safety. There was constant danger for individuals occupying second-floor rooms or perched on rooftops as the pounding waters and debris battered the houses. Eyewitnesses saw groceries, drugs, and jewelry floating away. The bleachers from Ranger Field, snagged by the swift current, rushed toward nearby houses, smashing the porch from 305 Hamilton Street. Every businessman suffered losses. The first floor of Peter Kanai's house was flooded about two feet; the funeral home chapel was sitting in six feet of muddy water. (Martin Savalchak.)

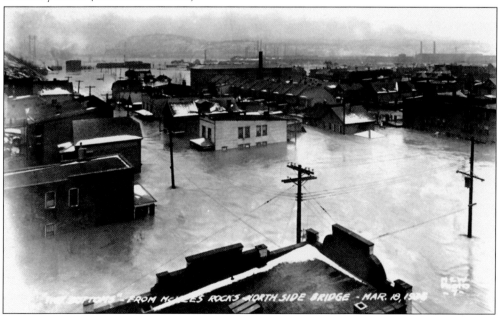

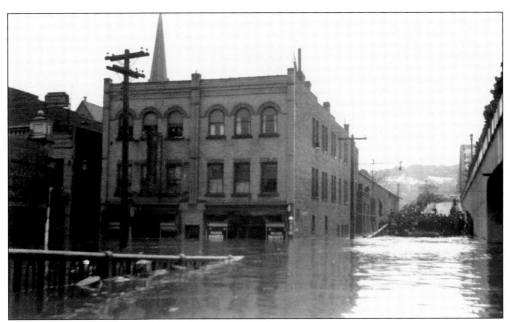

In the above photograph, people crowd the McKees Rocks Bridge ramp; in the photograph at right, a rowboat passes the Ahavath Achim Synagogue on Munson Avenue. One eyewitness later wrote in a family letter, "It was a Godsend for the Bottoms that the McKees Rocks Bridge was where it was. The four ramps served as landing places for boats. The stairways also served as landing places. People were being fed milk and bread by boat delivery. None wanted to leave their homes. As the water rose and gas and electricity were shut off, many people became panicky, especially with the arrival of night fall. Rescue boats started to increase in number. People were rushed to schools and hospitals . . . with everything in darkness, people screamed for rescue." (Above, Dorothy Kelly, photograph by Nicholas Sarandria.)

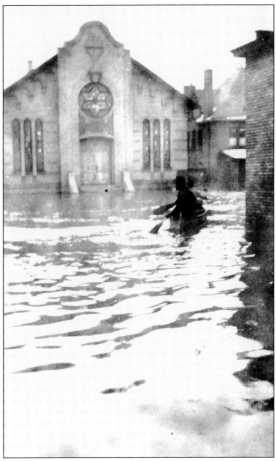

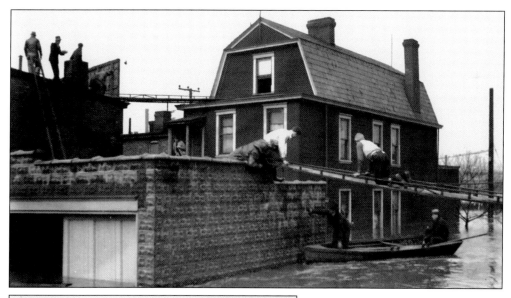

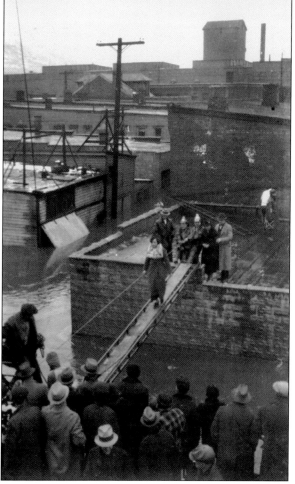

These two photographs illustrate getting flood victims to safety. Some 500 persons had been brought out of the Bottoms on March 18, most of them being housed in Blaine School on Island Avenue. Firemen lowered ladders and ropes from the McKees Rocks Bridge for those who could row to the bridge. On Helen Street, volunteers stretched boards across alleyways, creating an escape route from the bridge ramp to the building rooftops. Many victims were evacuated in this manner. Two men doing rescue work became victims themselves as their canoe tipped, and they were swept down Munson Avenue. One man caught on to a pole; the other snagged his sweater on a branch. Both were treated at Ohio Valley General Hospital in Norwood. As the water receded, all people were ordered out of the Bottoms, and the militia took charge. (Dorothy Kelly; photographs by Nicholas Sarandria.)

Eight

CHANGING SCENES

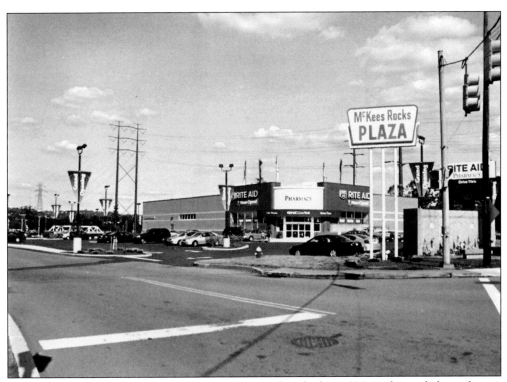

By the early 1950s, many of the buildings constructed in the late 1890s and crowded together on lower Chartiers Avenue were showing their age. With the Pittsburgh "Renaissance" already in progress, Allegheny County had funding available to revitalize selected communities, and McKees Rocks was chosen. However, little progress was made as politicians, planners, and business owners tried to reach agreements. The 15-year delay in building the McKees Rocks Plaza hurt hundreds of longtime business owners on both lower and upper Chartiers Avenue. (CDC.)

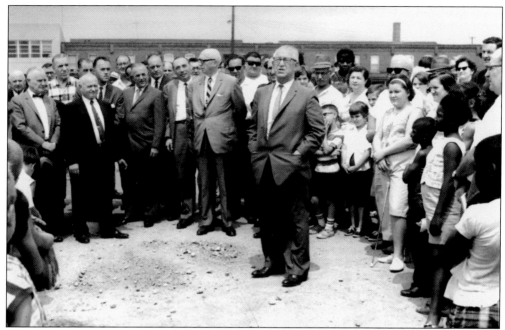

Mayor David Hershman (center) celebrates the groundbreaking of McKees Rocks Plaza in July 1966 along with county commissioner Dr. William D. McClelland, Albert G. "Rye" Trombetta, and Armand Seretti. A Russian immigrant and local businessman, Hershman built a political empire in McKees Rocks. People either loved him or hated him. A Democratic borough chairman for 30 years and mayor for 24, Hershman died in 1977 at age 85. (Ted Talkowski.)

Along with the many dilapidated and unsafe buildings on lower Chartiers Avenue, parts of Bell Avenue had become a popular red-light district. One of these establishments, Riley's Emporium, a three-story building located next door to a grocery store, can be seen to the left of this photograph. (Ted Talkowski.)

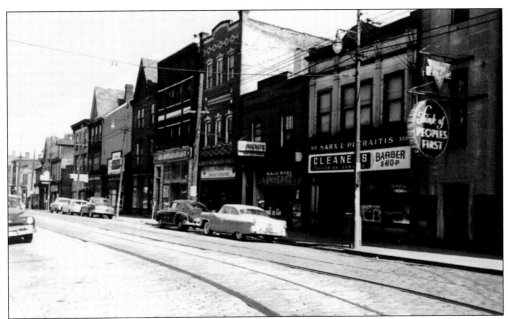

Taken in the late 1950s, these two photographs show both sides of lower Chartiers Avenue. When federal money became available for urban redevelopment projects, political discussions began in earnest. For six years, from May 1950 to September 1956, the Allegheny County Planning Commission studied McKees Rocks and determined that a portion of the first ward of the borough was blighted. In the photograph above, Marx and Petraitis Cleaners has replaced Baker's Cycle Shop, the scene of the 1931 McKees Rocks Motor Cycle Club photograph depicted on this book's cover. The image below shows the opposite side of lower Chartiers with the old municipal building, Pacienza Heating Company, and Superior Furniture Store. (CDC.)

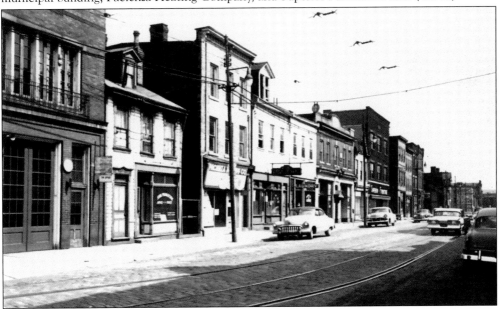

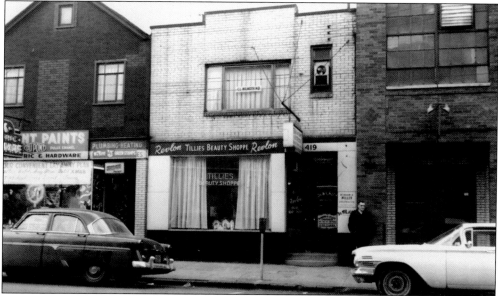

These are photographs of the three businesses that unsuccessfully tried to avoid the wrecking ball. The photograph above depicts Tillie's Beauty Shoppe and AK Hardware; the photograph below shows the interior of the Cory Records Store. After developer Michael Parrish paid $347,500 for 17.8 acres of cleared land, the County Redevelopment Authority made a change to the plan and included the relocation of Route 51. Three business owners, arguing that their properties were not condemned in the original redevelopment plan, filed an injunction in July 1963 against the County Redevelopment Authority to save their stores. The injunction also suggested that Mayor David Hershman, whose own buildings were spared, received preferential treatment. In the end, the small-business men lost, and Hershman was cleared of any impropriety. Since the state highways department had decided on a location for rerouting Route 51, those three businesses had to go. (Ted Talkowski.)

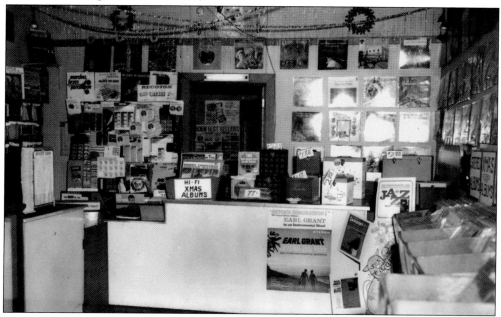

The photograph above looks across Chartiers Creek toward the old municipal building and the First National Bank of McKees Rocks (later Pittsburgh National Bank). The photograph below shows the location of the 1931 McKees Rocks Cycle Club book cover image (see page 63). Baker's Cycle Shop (later Max and Petraitis Cleaners) of 325 Chartiers Avenue is now just an empty lot . For a period of 10 years, one by one, business owners settled with the insurance company and set their date with the wrecking ball. Some businesses, holding out for a better settlement, stood alone to serve their dwindling customer base in the partially demolished lower Chartiers business area. In December 1965, two acres were separated from the main redevelopment site and sold to the Eat N' Park restaurant chain for $64,260. (Ted Talkowski.)

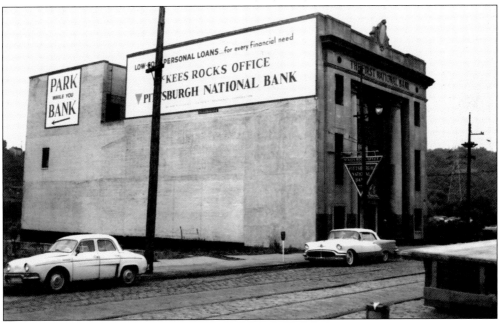

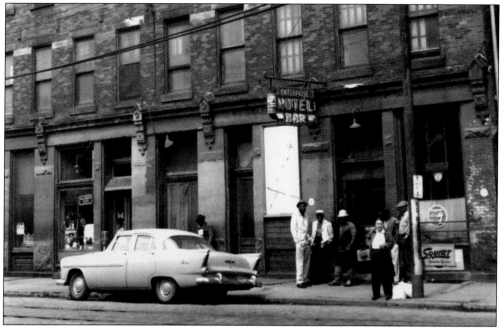

Men gather outside the Enterprise Hotel in this late-1950s photograph. The 60-room Enterprise Hotel, complete with bar, restaurant, and barbershop, opened its doors for business in 1888. Over the years, many fine caretakers hosted the Enterprise Hotel, starting with Theresa and Albert Gensch. By 1907, Jacob and Sophia Mosimann had taken ownership, which eventually passed to their son, John, after Jacob's death. John later sold the Enterprise Hotel and opened Mosimann's Hotel and Restaurant at 412 Chartiers Avenue. (Ted Talkowski.)

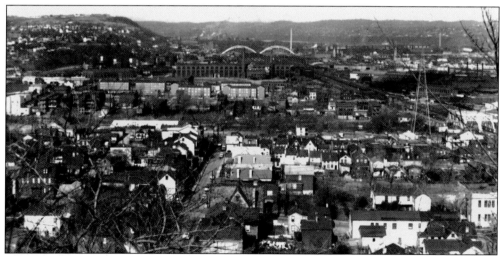

In July 1966, nearly 16 years after the idea of a revitalized lower Chartiers Avenue business district was conceived, Morris Deakter, an East Liberty developer, received the go-ahead to develop the property along Chartiers Avenue. He planned to build a $2 million shopping center, similar to the plaza he developed in Green Tree with 28 stores. Here is a 1958 aerial view overlooking Esplen toward the nearly cleared redevelopment area. Visible in the background are the Hays Manor buildings, the P&LE shops, and the McKees Rocks Bridge. (Ted Talkowski.)

Nine

LEARN AND WORSHIP

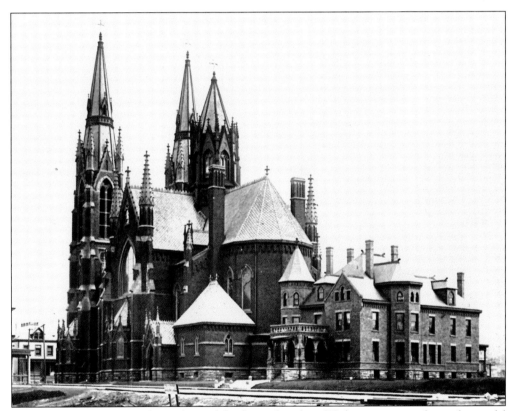

McKees Rocks is famous for its beautiful ethnic churches. With soaring steeples and graceful domes, they are reminiscent of old Europe. This is a photograph of St. Mary's Church, built in Flemish Gothic style, as it looked in 1905. St. Mary's Church added a new school in 1923. During the 1920s, many schools, both parochial and public, were constructed to accommodate the town's booming population.

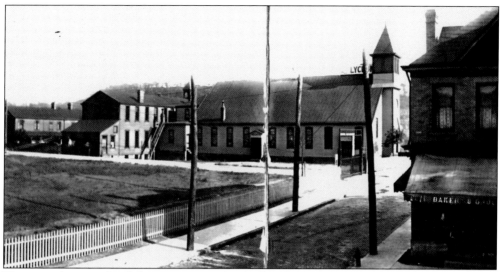

This is a photograph of the temporary school, church, and rectory, which served St. Mary's Parish from 1886 to 1900. These simple frame structures costing $7,500 furnished were intended to serve the parish until the permanent church could be built. They were first erected along Thompson Avenue on the site of the present church. When men began grading the foundation for the permanent church, they moved these temporary structures to this location on Thompson Avenue along the edge of the Leo Manor parking lot. (St. John of God Parish.)

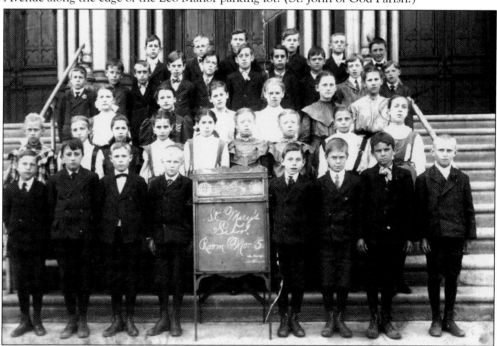

The children from room five of St. Mary's School pose for this c. 1905 school photograph, taken on the front steps of St. Mary's Church. Note the identical twins in the middle of the second row. Standing in the second row, second from the left, is Margaret Sonnet. Standing behind her, in the last row second from the left, is her future husband, John Rennekamp. (Roberta Rennekamp.)

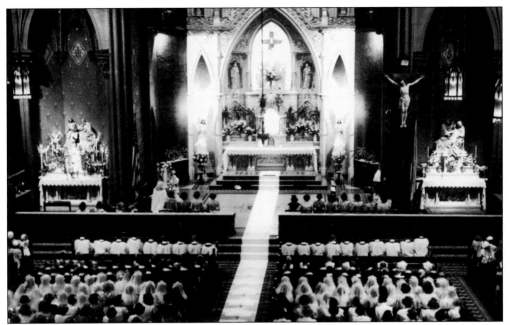

This photograph of the solemn celebration of First Holy Communion was taken from the choir loft in St. Mary's Church. St. Mary's Parish and the local parishes of Mother of Sorrows, SS. Cyril and Methodius, St. Francis de Sales, St. Maria Goretti, St. Mark, and St. Vincent de Paul in Esplen were merged on May 29, 1993, into the St. John of God Parish. (Roberta Rennekamp.)

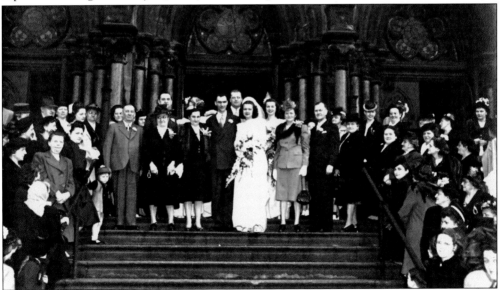

This is a wedding photograph of Regina Claire Yunker and Joseph Pandl taken on April 15, 1947. The bride's uncle, the Reverend Louis P. Yunker, performed the ceremony at St. Mary's Church. Claire Yunker is a descendant of John Yunker, whose furniture store, which started in 1882, was one of the oldest business establishments in McKees Rocks. Years later, the Pandls, along with June and Gerry Grogan, Betty Gerger, and others, worked for 17 years to make the Austrian Room, one of the 26 nationality rooms in the University of Pittsburgh's Cathedral of Learning, a reality. (Joseph Pandl.)

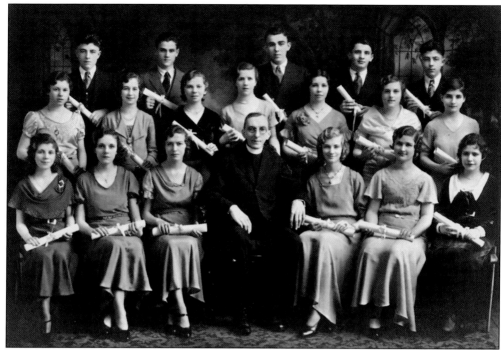

This is a 1932 class graduation photograph from St. Mary's High School. The graduates are, from left to right, (first row) Gladys Yunker, Jane ?, Mary Taus, Fr. Leo Meyer, Mary Habetler, Jane Baker, and Mary Bednar; (second row) Ann Hohmer, Mary Vavrek, unidentified, Hilda Stayduhar, Anna May Fisher, Teresa Bauer, and Agnes Fleishaker; (third row) ? Schmalzl, Eugene Hohl, John Stangl, Albert Sulzer, and ? Schmalzl. Following graduation, Teresa Bauer, Mary Bednar, and Mary Taus all entered the convent together. In 2007, all three celebrated 75 years as Sisters of Divine Providence. (Mary Sulzer.)

In 1891, St. Mary's Parish purchased nine acres from Alex McElroy for $7,000 for its third cemetery on Middletown Road. The 18-foot steel cross, which stands at the cemetery's highest point, is visible in the top center of this photograph. Today this same view looks entirely different. Hundreds of neatly lined rows of graves in Mount Calvary Cemetery, along with the construction of the redbrick caretaker's house, have transformed this grassy meadow in the foreground. (St. John of God Parish.)

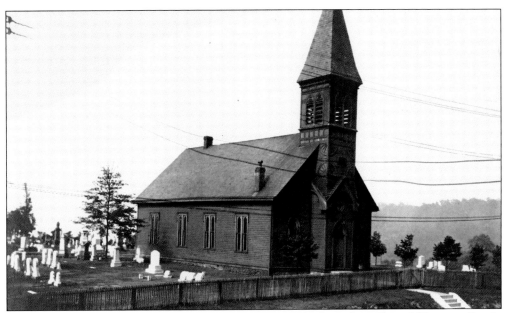

Mount Calvary Lutheran Church at Duff's Station, overlooking the valley of Chartiers Creek, was dedicated on September 4, 1853, and served the community until 1887. It was the first of three churches built to serve this congregation. Early settlers first gathered at the home of Martin Clever Sr. for services and were led by the Reverend Henry Reck. The second church was built at Chartiers Avenue and Linden Street. The third and existing church is located on Russellwood and Dale Streets. (Good Shepherd Lutheran Church.)

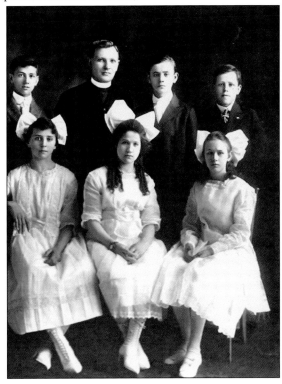

This c. 1915 confirmation photograph hangs in Good Shepherd Lutheran Church on Russellwood Avenue. Note the high-top button shoes and bows on the women. The Reverend Dr. A. Boerstler promoted growth in the congregation. (Good Shepherd Lutheran Church.)

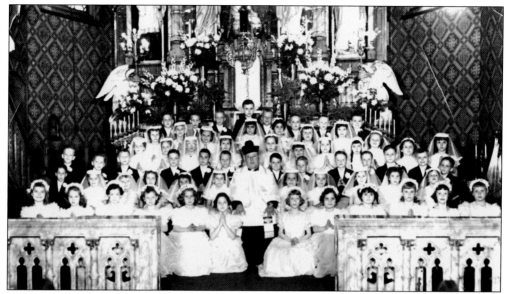

This is a photograph of a St. Mark Church First Holy Communion class from the 1960s. The church, located on Munson Avenue in the Bottoms, was founded in 1906 as a Slovak parish. A new school and convent were dedicated on Thanksgiving Day 1928. In the 1969–1970 school year, St. Mark School was merged with SS. Cyril and Methodius School due to decreasing attendance in both schools. (Nick Radoycis.)

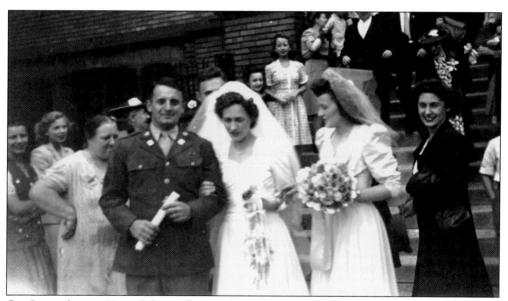

On September 4, 1944, S.Sgt. Albert Sulzer, after securing a 14-day furlough, married his longtime sweetheart, Mary Lesko, at St. Mark Church on Munson Avenue in the Bottoms. Maid of honor Ann Vukovich, standing beside the bride in this photograph, later married John Kasich, a McKees Rocks mailman. Their son, John Richard Kasich, is a former nine-term United States congressman, a Fox News Channel political commentator, and a best-selling author whose book, *Stand For Something*, is rooted in values learned while growing up in McKees Rocks. (Mary Sulzer.)

This is a photograph of the current St. Mary Ukrainian Church, which was built in 1923. It was organized in 1906 by a small group of Ukrainian immigrants. The Reverend Peter Luchechko was its first pastor. In 1940, a group of parishioners who wished to be affiliated with Rome left to form St. John the Baptist Ukrainian Catholic Church after a court delivered a decision favoring the Orthodox.

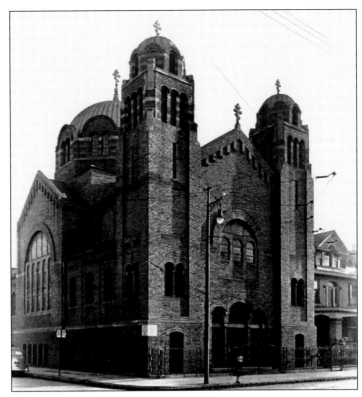

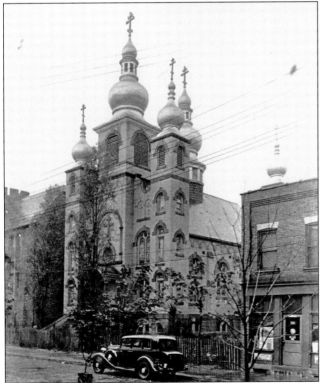

This photograph of St. Nicholas Church, located at 320 Munson Avenue in the Bottoms, was taken in 1937. Early Slavic immigrants to McKees Rocks, having no Orthodox church in the area, bravely crossed the Ohio River by boat to attend services at St. Alexander Nevsky Parish in the Woods Run section of Pittsburgh. Incorporated in 1914, the church features onion domes, typical of Byzantine architecture, and the three-barred Russian cross.

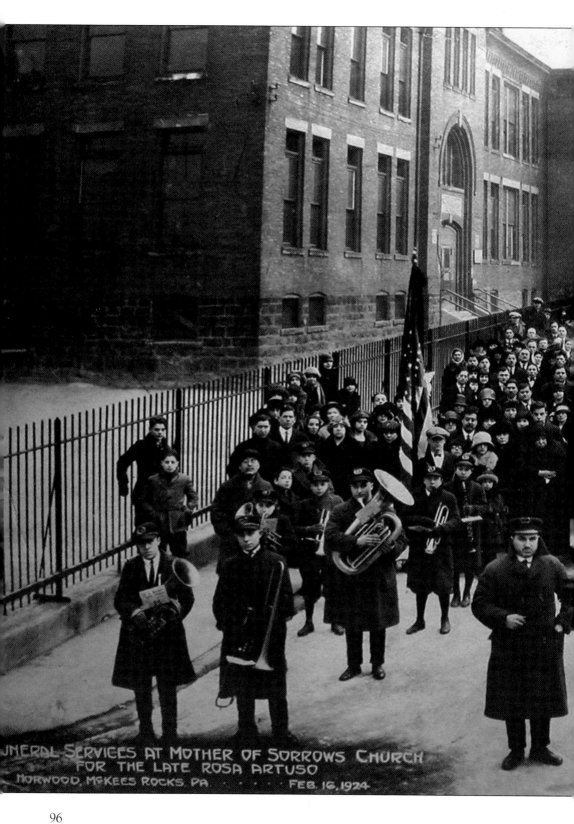

UNERAL SERVICES AT MOTHER OF SORROWS CHURCH
FOR THE LATE ROSA ARTUSO
NORWOOD, McKEES ROCKS, PA FEB. 16, 1924

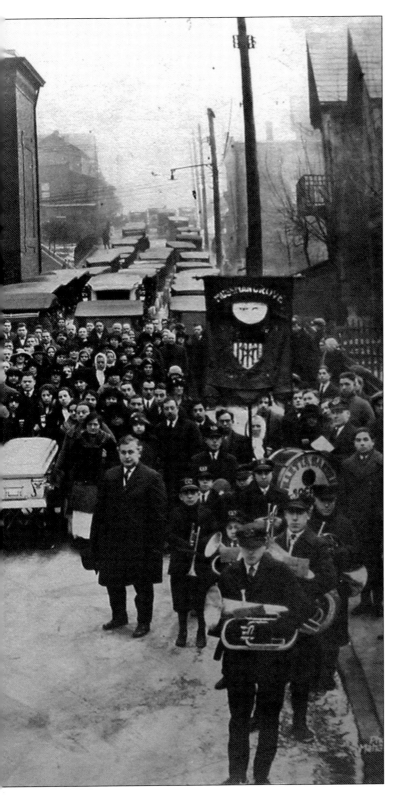

This antique 1924 photograph eloquently portrays the Italian community's outpouring of grief, love, and respect for Rosa Artuso. Vintage cars line upper Harlem Avenue as the crowd fills the street next to the Norwood School. Here the residents of Norwood stand on the street and curb to pay their respects. A young Dr. Ed Clements leans against the school fence while a boyish Chuck Liberatore, member of the Italian band, stands stoically holding his trumpet next to Stover funeral director, R. Hayes Clever. Antonina Presutti, wearing a wide-brimmed hat, is visible a few rows behind the coffin. It was typical for the procession to travel, accompanied by the local band, from the church to the cemetery. (Anthony Musmanno.)

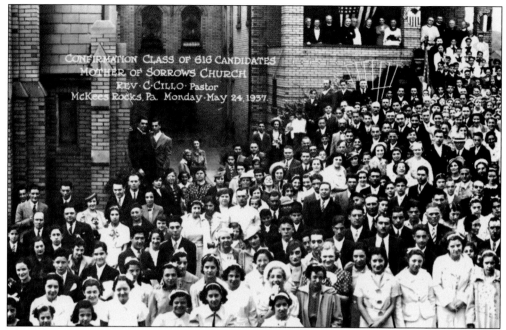

This photograph captures a neighborhood event after 616 members of Mother of Sorrows Church were confirmed by the Reverend Carmine Cillo on May 24, 1937. Mother of Sorrows Church started as a mission in 1904. In 1906, the parishioners raised enough money to purchase property at 92 Harlem Avenue in Norwood. Mother of Sorrows Church has had several different locations in its history. (June Grogan.)

Here is a photograph of the McKees Rocks United Methodist Church. The first church was built in 1888 at the corner of Bell and Linden Streets. However, because of frequent flooding, the congregation erected a new church at the corner of Rose and Yunker Streets in 1905. In 1974, the church merged with the McKees Rocks Presbyterian Church. This structure was later used as Linder Furniture Store. (Tom Berilla.)

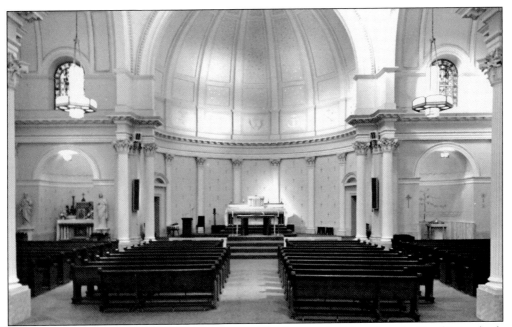

This photograph shows the beautiful interior of St. Francis de Sales Church. Combining both Byzantine and Romanesque styles, architect Marius Rosseau, who lived in Bellevue, modeled St. Francis de Sales Church after the basilica in Milan. Completed in 1899, the church had 32 stained-glass windows, fluted columns with gilded capitals, a soaring rotunda, and a handcrafted stone exterior. (St. John of God Parish.)

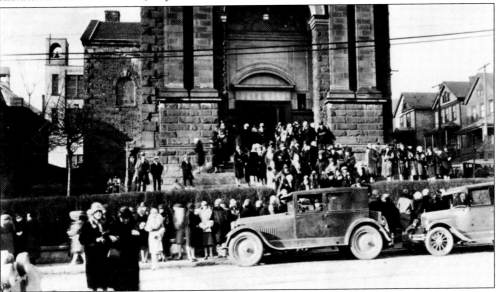

In this 1930 photograph, parishioners descend the steps of St. Francis de Sales Church following a funeral service. St. Francis de Sales Parish was formed from territory that had been part of St. James Parish in the West End and St. Phillips Parish in Crafton. The Reverend Francis Tobin celebrated the parish's first mass in October 1888 at the Enterprise Hotel. In 1889, the growing parish erected a combined church and school building at Mary and First Streets. (St. John of God Parish.)

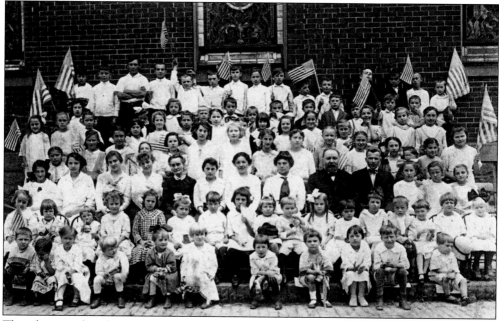

This photograph, taken in the summer of 1916, shows a vacation bible school group resting in front of one of the oldest churches in West Park. Today this building sits across from Mancini's Bakery on Sixth Street and Woodward Avenue. The original framed structure, built in 1905, was known as the West Park Pentecostal Tabernacle. Its beautiful stained-glass windows were donated as memorials. The West Park Mission of the Presbyterian Church purchased the building at a sheriff's sale in July 1912. (Mary Lou Rote.)

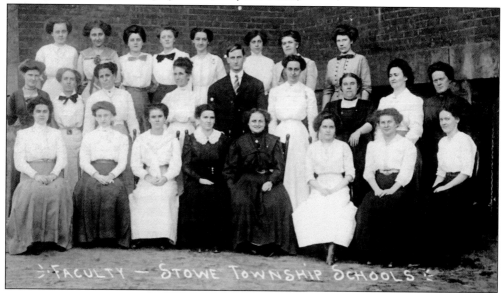

This 1900s photograph of the faculty of Stowe Township Schools was taken in front of Norwood School. Stowe Township, named in honor of Edwin H. Stowe, a prominent Allegheny County judge, separated from Robinson Township on December 6, 1869, to become an independent township. Early Stowe Township neighborhood schools included Norwood, Presston, West Park, and Davis. Stowe Township maintained an independent high school from 1928 to 1966.

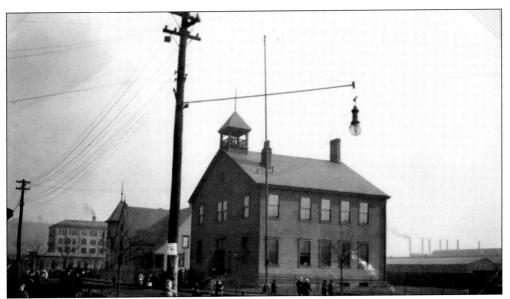

Here is a c. 1915 photograph of the wooden-framed Presston School house, which operated from 1902 to 1961; notice the vintage streetlamps. The school was located on Ohio and Center Streets and housed grades one through three; grades four through six went to the Davis School. Often used as a meeting place during political campaigns in the 1930s and later as a storage and polling station, the school was demolished in 1964.

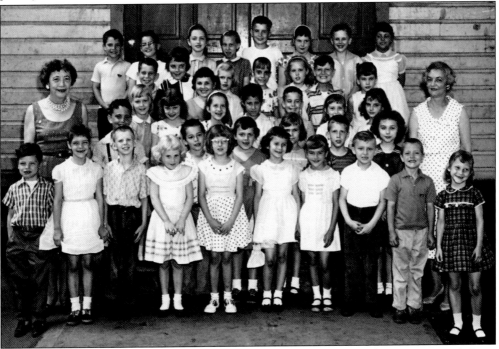

This 1961 photograph of the last class of Presston School includes grades one, two, and three. Gene Eddie, who operated a photography studio for many years at 308 Helen Street, took this photograph. This was the last group of children to attend the Presston School. Principal Nancy Walters, with the beaded necklace, stands to the left, and next to her is John Makar.

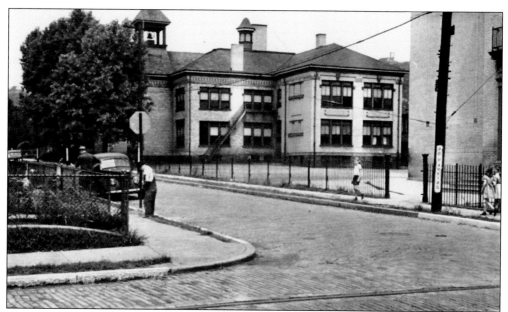

This is a photograph of the West Park School that stood at the intersection of Broadway, Dohrman, and Russellwood Avenues. It was built around 1901 to accommodate the children moving into the new West Park Lot of Homes. One room of the West Park School was used by the new McKees Rocks High School when it started in 1912. West Park School served Stowe Township for many years. In 1930, two new elementary schools, Foster and Fenton, were built.

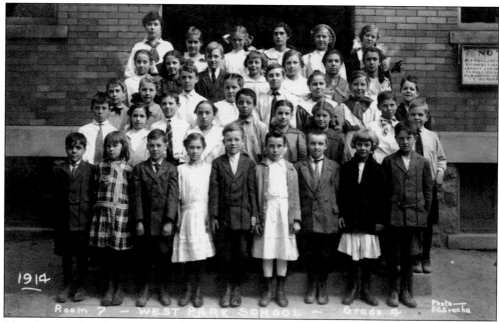

This photograph, taken in 1914 in front of the West Park School, shows the classmates belonging to the fourth grade. Marie Stikarofsky stands on the far right in the fourth row. Marie lived with her parents, Anton and Mary Stikarofsky, and her three sisters, Emma, Alice, and Helen, and brother, Jacob, at 1103 Twelfth Street in West Park. (Mary Lou Rote.)

102

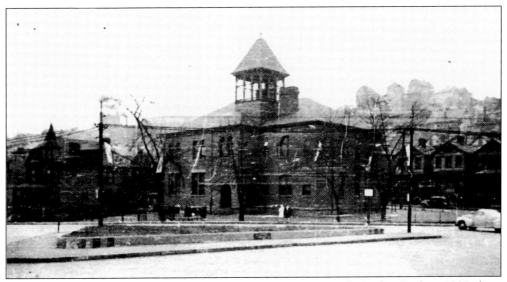

The Blaine School stood on Island Avenue near the McKees Rocks Bridge. Built in 1888 along with the McKee School on Chartiers Avenue, it predates the incorporation of the borough in 1892. The Blaine School was a traditional brick schoolhouse with a bell tower and a wrought-iron fence. During the flood of 1936, it housed many residents who were forced to leave their homes in the Bottoms. Blaine School was demolished in 1966.

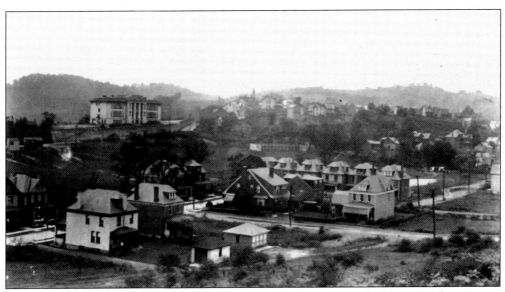

This vintage photograph shows a stately Ellsworth School sitting high above Greydon Avenue and Vine Street on Chartiers Avenue Extension. Ellsworth School, with students from both McKees Rocks and Stowe Township, opened as the new McKees Rocks High School in February 1914. Later used as an elementary school, Ellsworth served as the high school until 1928 when Miles Bryan High School opened. (Jan Condeluci Uhler.)

Hamilton School, named for Samuel Hamilton of the Hamilton arithmetic textbook series, was built in 1923. Although the district made plans for building this school early in the century, a long legal entanglement over the abandonment of the original foundation delayed its completion until 1923. Originally this building was used as an elementary school and a junior high school. (Ted Talkowski.)

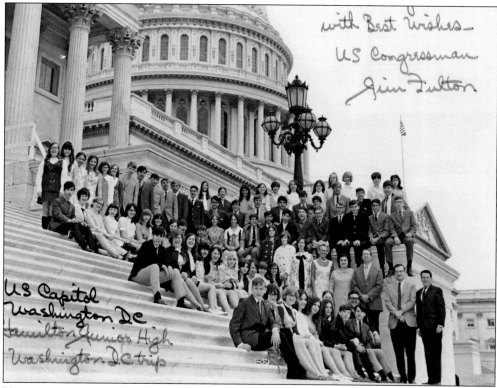

Here is a commemorative photograph of the Hamilton Junior High trip to Washington, D.C., in May 1969. The students met with U.S. congressman Jim Fulton on the steps of the United States Capitol. Fulton, a native of Dormont, Pennsylvania, was elected as a Republican in 1944 and served until his death in 1971.

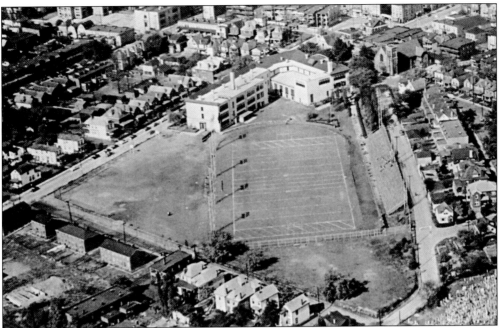

This aerial view of Stowe High School, used in 1956 as the inside cover of the *Echo* yearbook, offers interesting views of Stowe. Located on one point of a large triangle, Stowe High School is defined by Rosamond, Dale, and Valley Streets. Both the West Park and Foster Schools are visible near the top right. First Baptist and Good Shepherd Church stand just beyond the school. Dating from 1900, the Beth Hamedrish Hagadol-Beth Jacob Congregation Cemetery is on the lower right of the photograph.

Stowe High School and McKees Rocks High School maintained a fierce rivalry for nearly 40 years until the two high schools merged in 1966. The first matchup in 1928 ended in a 12-12 tie. The Rox Rams, coached by Toby Uansa, were at a disadvantage having no home field; they usually played their home games on Stowe's field. During the Stowe and Rox rivalry game, horse-mounted troopers made sure fans remained orderly as the Rox Rams and the Stowe Stallions battled out the game. (John Hopay.)

This 1950s photograph shows James P. (Jim) Crivelli of Crivelli Chevrolet presenting a car to Stowe High principal Dr. Neal V. Musmanno for use in the school's driver education program. Born in 1916 in Aliquippa, Crivelli worked in his parent's grocery store and gas station before starting the Chevrolet franchise in 1955. (Jim Crivelli.)

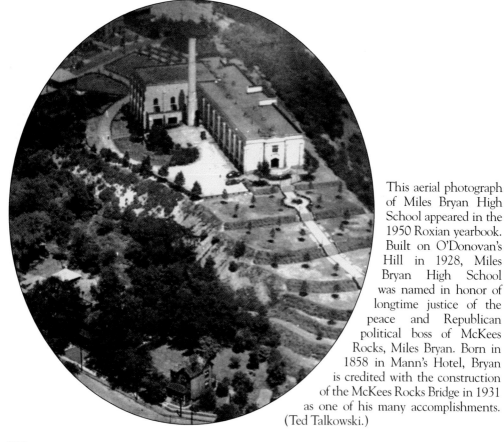

This aerial photograph of Miles Bryan High School appeared in the 1950 Roxian yearbook. Built on O'Donovan's Hill in 1928, Miles Bryan High School was named in honor of longtime justice of the peace and Republican political boss of McKees Rocks, Miles Bryan. Born in 1858 in Mann's Hotel, Bryan is credited with the construction of the McKees Rocks Bridge in 1931 as one of his many accomplishments. (Ted Talkowski.)

Ten

REMEMBERING FACES AND PLACES

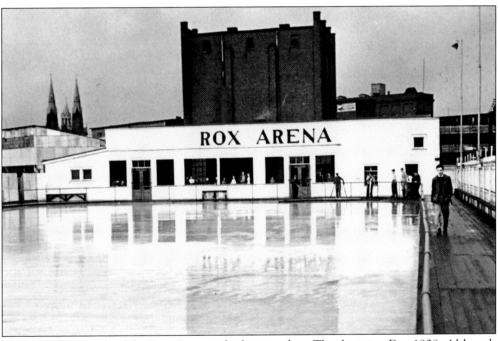

This is a photograph of the Rox Arena, which opened on Thanksgiving Day 1938. Although it was forced to close between December 1942 and November 1946 because needed materials were diverted to the war effort, the ice arena was always someplace special. Some weekends upward of 500 skaters would come. The Singer Ice Company, owner of the Rox Arena, supplied its refrigeration, requiring over 11.5 miles of one-inch pipe to keep the surface frozen. The rink closed in 1950. (Bob DiCicco.)

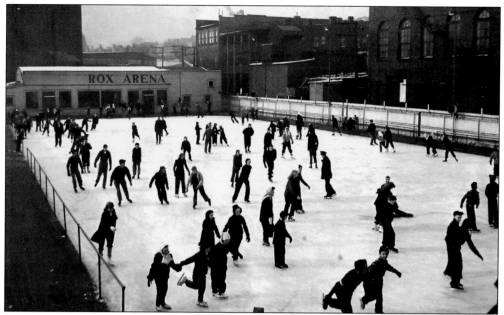

Equipped with lights for nighttime skating, the Rox Arena had become one of the most popular outdoor recreational centers in Allegheny County. Young skaters, like Dolores Corbett, a five-year Ice Capades performer, practiced at the rink. She and husband Pete Pateas lived upstairs of the Chartiers Restaurant. In February 1941, the arena featured 20 event outdoor speed skating championships. Of the 46 participants, 7 were from McKees Rocks. (Bob Singer.)

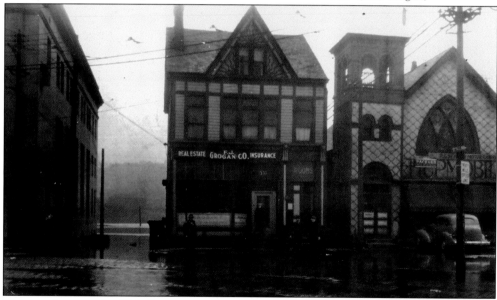

This is a photograph of F. J. Grogan standing in front of his real estate business at 331 Chartiers Avenue during the April flood of 1937 when the rivers crested at 10 feet above flood stage. Grogan opened his business originally on Bell Avenue in 1917 when he was 26 years old and moved to 908 Chartiers Avenue in 1946. The Hupmobile dealership was previously the second location of the Mount Calvary Evangelical Church, dedicated on November 21, 1897. (Gerry and June Grogan.)

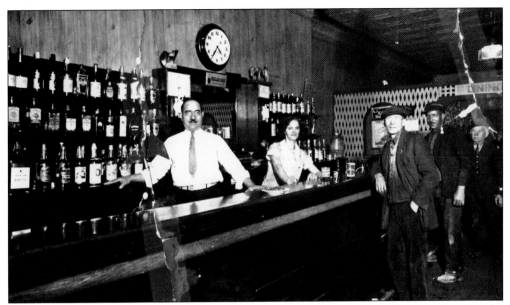

Rose and Ivan Vrcek are seen tending to their customers in this 1920s photograph in Vrcek's Restaurant in the Bottoms. The restaurant had a dining room where polka bands kept everyone tapping their toes. Today there is a small park near the McKees Rocks Bridge where this establishment once stood. This couple, parents of three sons, emigrated from Croatia in 1914. (Taris Vrcek.)

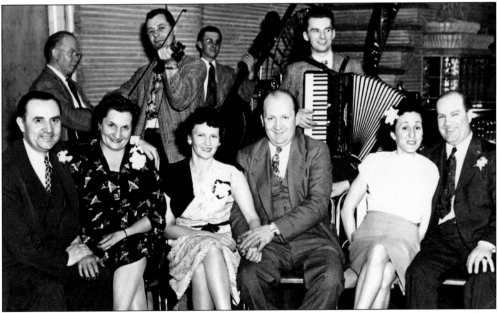

The McKees Rocks Maennerchor, a German social club on Frank Street, was incorporated on June 4, 1892. *Maennerchor* is a German word meaning "male choir." At one time, it had over 800 members and hosted dances and celebrations of all kinds. Seated in this 1940s photograph, from left to right, are Joe and Theresa Pandl, Frances and Rudy Gerger, and Frances and Joseph Gerger. Joe Schoenbeck and his orchestra provided the entertainment for this occasion. (Joe Pandl.)

This late-1940s photograph shows a trolley on Chartiers Avenue having just passed St. John's Evangelical Lutheran Church located at the intersection with Yunker Street. This yellow brick structure was the successor to the "Little German Church" built on the same site in 1887.

This charming 1960s photograph captures the image of several generations of dedicated Pierogi Ladies from St. Mary Ukrainian Church in the Bottoms. Standing on the left is Catherine Makar; fourth from the left is Catherine's daughter, Helen Makar Conrad. Founded in 1906, St. Mary Ukrainian Orthodox Church holds an annual parish festival every summer to promote the Ukrainian culture, its history, and its people.

This late-1940s photograph was taken at the corner of Island Avenue and Chartiers Avenue. The trolley is getting ready to make the turn on to Chartiers Avenue, passing under the PC&Y trestle that was raised above street level in 1911, and continue into downtown Pittsburgh. (Pennsylvania Trolley Museum Collection and John Makar.)

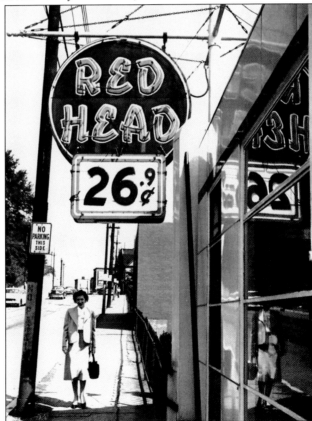

This photograph was taken on September 3, 1958, of the Red Head Gas Station on Island Avenue approaching the PC&Y crossing trestle. Red Head was a longtime Ohio private brand that dated back to the early 1930s. The company was successful for many years but finally sold out to Ashland Oil in the early 1970s. (CDC.)

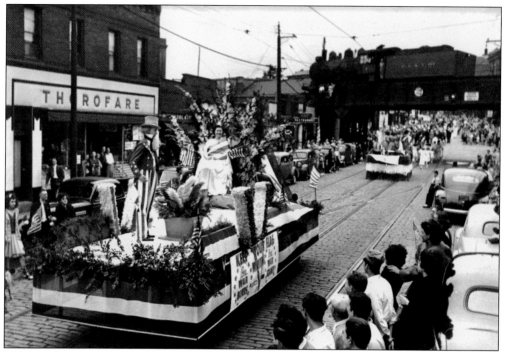

This parade scene was photographed on June 14, 1942. Notice the PC&Y engine on the railroad trestle as Uncle Sam and Lady Liberty ride down Chartiers Avenue on a beautifully decorated float with fresh flowers. They were encouraging everyone along the parade route to "Keep your Flag Waving; Buy War Bonds." (Dave Dietz.)

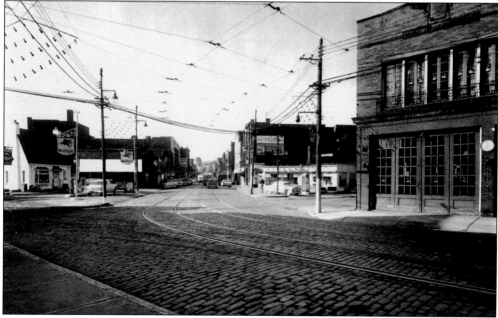

This late-1950s photograph gives a long view north up Chartiers Avenue toward St. Francis de Sales. The trolley tracks are a prominent feature in this photograph. Visible are the old-style Christmas bulbs already decorating this outdoor scene. (Dave Dietz.)

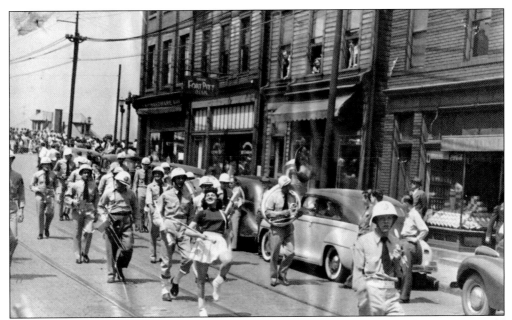

This is a photograph of the 1946 victory parade held to honor all returning hometown World War II veterans. Majorette Lita Gargaro marches with the VFW band down the upper end of Island Avenue near the McKees Rocks Bridge, as spectators watch from second-floor windows and the street. The VFW Post 418 band, under direction of Robert McCarter, had 50 members and provided music for community parades, special occasions, and local civic and patriotic functions. (Lita Gargaro Fuze.)

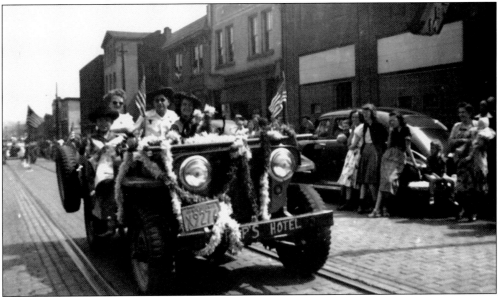

Here is another snapshot of the 1946 victory parade as it made its way down Broadway in West Park. Driving the army jeep is Marie Trapuzzano with passengers Pat, Madeline, and Anthony Trapuzzano. This jeep was restored and is now in Arizona. To the right, three young women are seen leaning against a car parked in front of the Globe Restaurant, bought by the Gargaro family in 1950. (Patrick Trapuzzano.)

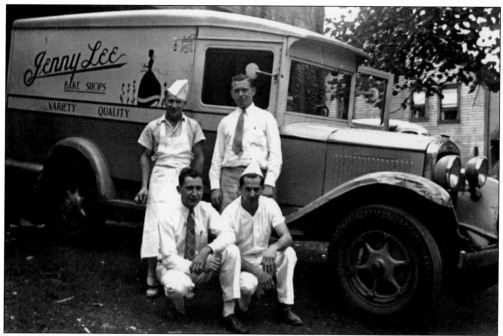

In 1938, Paul Baker, grandson of the Seven Baker Brothers founder Michael Baker, partnered with cousin Bernard McDonald to open Jenny Lee Bakery in the G. C. Murphy store, Market Square, in downtown Pittsburgh. In February 1942, they moved to 618–620 Island Avenue. The name Jenny Lee Bakery came from a song the two cousins heard while on their way to a business meeting. "Sweet Jenny Lee from Sunny Tennessee" was playing on the radio, and it sounded like a good name for their new bakery. (Jim and Pat Baker.)

In this 1969 photograph, the McKees Rocks Rotary celebrates goodwill and the Christmas spirit at the annual Rotary Christmas party. The Rotary organization of McKees Rocks hosted a yearly Christmas event for the local children. In this photograph, Al Burgunder and Vince Darby deliver fresh Jenny Lee Bakery cookies to neighborhood children. (Ted Talkowski.)

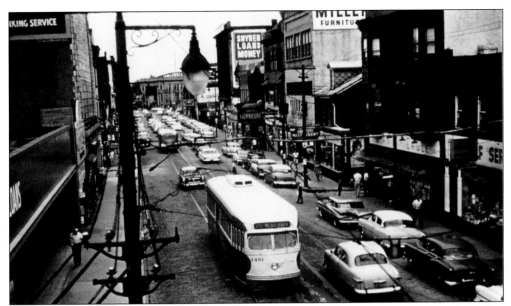

This is a 1959 photograph of a familiar sight on Chartiers Avenue, the No. 26 West Park Trolley. Chartiers Avenue was always busy with traffic, and parking was permitted on both sides of the street. The First National Bank, later the McKees Rocks office of the Pittsburgh National Bank, can still be seen at the top of the photograph as Chartiers Avenue curves left toward the businesses on the lower half of the avenue. (Pennsylvania Trolley Museum Collection and John Makar.)

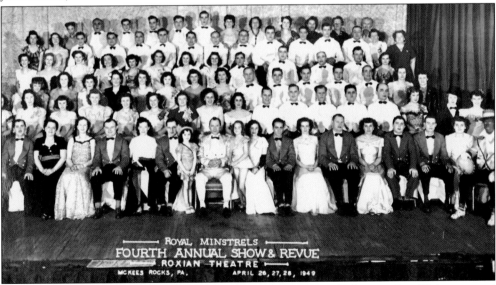

For several years, the Kiwanis Club, Junior Ladies Aid Society, and Maennerchor Club sponsored a talent production, known as Dixieland Minstrel Show and Revue, at the Roxian Theatre to benefit various charities. These were major productions that attracted over 1,000 people each night for a three-night run. These highly successful productions featured all McKees Rocks talent, including many faces from the Holy Ghost Choir. Bill Burgunder, Joe Stayduhar, Fred Kennedy, Edward Chekan, Helen Uram, John Fejka, Joe Butchko, and many more were all a part of these memorable productions. (Gene Thomas.)

This 1956 parade passes in front of the Commonwealth Hotel. Miles Bryan, a descendant of early settlers James and Mary Bryan, bought the hotel shortly after it was completed in 1898. (Aaron Trapuzzano.)

In the early 1970s, Jim Hollowood opened his first Hollowood Music and Sound Store on Chartiers Avenue. Music enthusiasts, including some long-haired, guitar-loving teenagers, loved to hang out here. Hollowood was one of the first retailers to rent out sound equipment to fledgling artists. Jim Hollowood was an accomplished musician who studied at Carnegie Tech and worked with many groups, including the Sammy Kaye Orchestra. (Don Hollowood.)

This photograph of a group of bakers was taken at Mancini's Bakery at the Woodward Avenue location. Jimmy Mancini started the bakery in 1927 in one rented room where he made 100 loaves of bread per night and delivered fresh bread in the morning. In the mid-1940s, Ernest Mancini and Jimmy joined their efforts together and moved the bakery to 601 Woodward Avenue. Earnest operated the bakery 24 hours a day and made more than 10,000 loaves of bread daily. Mary Mancini Hartner, following in her dad's footsteps, runs the bakery now. (Mary Mancini Hartner.)

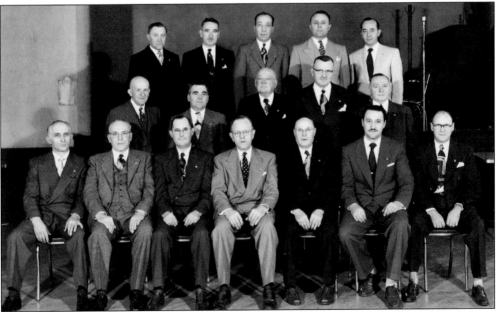

The Workingmen's Beneficial Union (WBU) was founded in 1907. The first meeting was held at the residence of John Laut on Olivia Street where the first officers for 1907 where elected and installed. In 1942, officers were Frank Anzenberger, John Reisinger, Harry Koller, Dal Maddalon and Edward Sulzer. Anzenberger, active in community affairs, was serving his third term in the chair as president. (Catherine Anzenberger Holmes.)

This is a classic mid-1950s photograph of cars turning at the Five Point Inn to travel across the Windgap Bridge. The car at the bottom right of the photograph is parked diagonally in front of the Mann's Hotel. Framed by Miles Bryan High School on the left and St. Mary's Church on the right, this scene depicts a neighborhood softball game in progress at Vets Field. (Author's collection, photograph by John A. Sulzer.)

This is a late-1950s photograph of a neighborhood fair held near the old Vets Hall and Field. Vesle Post No. 418 of the VFW was organized on May 24, 1920, in the McKee School with 45 veterans and opened on Memorial Day 1930. Following World War II, the VFW bought all the property formerly known as the Abe Mann playground and built a large adjoining parking lot. This location was later occupied by the Kroger Store and Pat Catan's. (Author's collection, photograph by John A. Sulzer.)

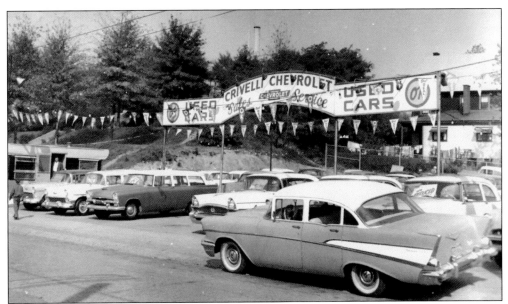

Here is a photograph of the Crivelli Chevrolet used car lot located next to Larry Lanza's Park Bowling Alley on Chartiers Avenue. Notice the little pink trailer that was used as the office and the smokestack of Miles Bryan High School in the background. In 1955, when Crivelli Chevrolet moved to 1123 Chartiers Avenue, it opened a new showroom, body shop, and parts department and established this used car lot across the street. (Crivelli Chevrolet.)

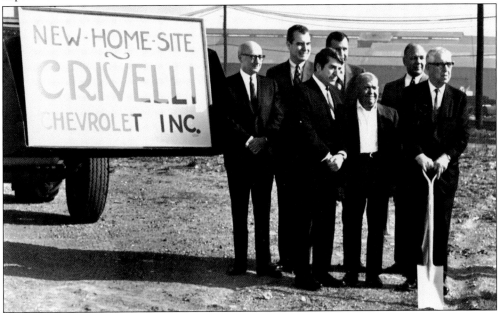

Jim Crivelli and Crivelli Chevrolet have been a McKees Rocks institution since 1955. With the new shopping area completed, Crivelli Chevrolet opened a brand-new facility at the end of the McKees Rocks Plaza in 1970. In addition to building a larger, indoor showroom, Crivelli Chevrolet also centralized service, parts, and a body shop. In this photograph, Jim Crivelli stands on the new site with his dad, Nicola, who started out with a two-pump gasoline station and grocery store on Island Avenue in 1928. (Jim Crivelli.)

An antipoverty program started in 1969 in conjunction with the Diocese of Pittsburgh, Focus on Renewal (FOR) addresses the needs of the community. In 1981, the old A&P grocery store on Thompson Avenue was retrofitted for use as the new FOR Health Center. Standing in front of the future health center are Sr. Ruth Bearer, associate director, who has been with the FOR since 1981, and Fr. Regis Ryan, executive director. (Focus on Renewal.)

FOR was holding its health fair in October 2001 when this photograph was taken. FOR provides medical and dental services, runs a credit union and thrift store, offers drug and alcohol counseling, teaches adults to read and pass the GEDs, operates a senior citizens' high rise and a van service, and opened a cultural center in 2008. (Focus on Renewal.)

For more than 25 years, the community of Pittock has gathered every summer for a reunion. They reminisce about the old Davis School, the No. 25 Island Avenue trolley turnaround, Vaseline Showground, High Road, Trap's Hotel, Glen Way, Shane Hollow Road, and the now defunct Pittock zip code, 15141. A Stowe Township neighborhood, Pittock is located near the Fleming Park Bridge and Neville Island. Seen in this 1983 reunion snapshot are, from left to right, (first row) ? DeAngelis, ? Urbano, and three unidentified; (second row) Chester Litterini, Whitey Mehalick, Pat Trapuzzano, Madeline Trapuzzano, Tony Bennett, and Joseph Amicone. (Patrick Trapuzzano.)

This photograph of Pat Trapuzzano, galloping down the streets on his horse, Silver, epitomizes the free spirit and exuberance of this well-known Pittock resident who was the longtime owner of Trap's Hotel. Trapuzzano was born aboard ship on Christmas Day 1903 as his parents traveled from Italy to America. He passed away in 2000. (Patrick Trapuzzano.)

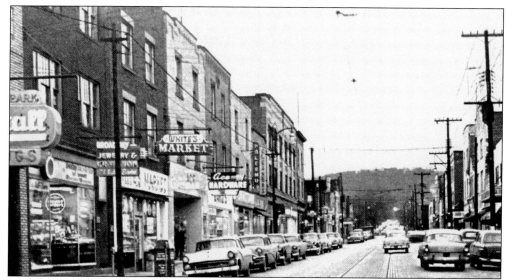

This image of Broadway from the 1950s should bring back memories. Here within walking distance from home and school were a variety of stores. White's Market, Ace Hardware, Palermo Cleaners, and dozens of others lined both sides of the street. In 1983, the Broadway Development Corporation restored business facades and added old-style lampposts in West Park along Broadway, giving the business district an early-20th-century appearance.

In this 1982 photograph, Tony Gargaro and the West Park Firemen's Band parade down Broadway. Founded by Francis Bjalobok, the West Park Firemen's Band included many former members of the Sto-Rox or Montour bands. Every spring, the band gathered for practices in the second-floor room of the firehouse, preparing for the parade season. Traveling by school bus to town festivals all over western Pennsylvania, the band marched in one or two parades every week during the summer. (June Gargaro Henry.)

A favorite recreation spot located on Locust Street in McKees Rocks, Brannan's Bowl has hosted many bowling leagues through the years. Seen in this photograph are four members of the 1970–1971 Knights of Columbus Bowling League that bowled every Wednesday night. From left to right are Tim Burns, Larry Cersosimo, Phil Haushalter, and Joe Skrak. (Liz Matergia.)

Patrolman Steve Homer is pictured under the marquee of the Parkway Theater early in his career. Homer began as a patrolman in 1957 and was promoted to assistant chief in 1972 and chief of police in January 1973. Serving his entire career in Stowe Township, he served longer than any policeman and police chief in Stowe history. Homer retired from the force exactly 45 years after he started, on February 1, 2001. (Sue Homer Bennardo.)

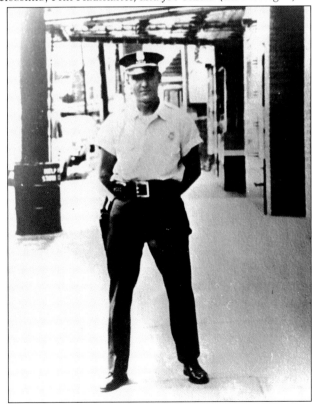

Maddalon's Bar, built in 1941, was a popular destination at 525 Broadway. For the adults, there was music and dancing every Wednesday, Friday, and Saturday night, and for children, there were Saturday morning movies. During the war, the bar's basement served as an air raid shelter for McKees Rocks and was equipped with water, canned goods, and gas masks. Standing in this 1966 photograph outside Maddalon's Bar at 525 Broadway are, from left to right, John Abraham (bartender), Dal Maddalon, and Harry Hoffman. (Janine Maddalon Mogan.)

This is a photograph inside Sulzer's Tavern, a popular establishment located at 708 Broadway in West Park. The tavern was owned by Joseph Sulzer and family until July 1989. Seen here are Joe Sulzer and son-in-law Steve Fekety behind the bar. (Mary Lou Rote.)

This 1995 photograph shows siblings Frank, Mary, and George Traupman sitting together at the counter of the McKees Rocks Eat n' Park. Their parents, Ignatz and Hermina Traupman, emigrated from Burgenland, Austria, and settled on Railroad Street. George Traupman served as a borough secretary in McKees Rocks. Mary Traupman, a member of the Sisters of Divine Providence and an attorney, ministers to the elderly. (Mary Traupman.)

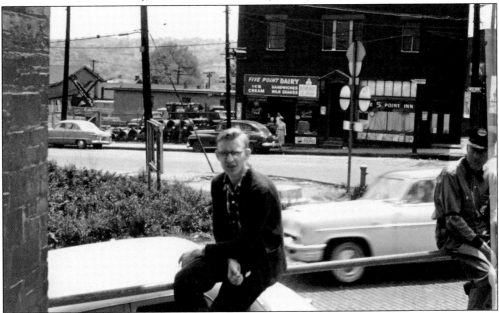

This is a late-1950s photograph of the Five Point Inn, taken from the Esso station. The Five Point Inn, located at the upper end of Chartiers Avenue, was across the street from the Windgap Bridge and Mann's Hotel. Notice the gas station attendant dressed in the Esso uniform to the right of the photograph. (Author's collection, photograph by John A. Sulzer.)

This late-1950s snapshot captures an image of a summer long ago. Three unidentified friends sit on a bench outside Mann's Hotel and watch the traffic go by near the Five Point Inn. (Author's collection, photograph by John A. Sulzer.)

Now among the classification of "things that aren't there anymore," this suspension footbridge once spanned Chartiers Creek. Damaged by floodwaters due to Hurricane Ivan in September 2004, it was taken down the following year. In 1876, a covered bridge, known as the White Bridge, served travelers from Windgap to McKees Rocks in this same location. (Terri Angell.)

ABOUT THE
MCKEES ROCKS
HISTORICAL SOCIETY

The McKees Rocks Historical Society was founded in 2007 to encourage community interest in the history of this area by collecting, preserving, exhibiting, and interpreting our past to people of all ages.

Our aim is to sponsor neighborhood pride and foster appreciation for all historical materials that enrich our understanding of the past as well as the present.

Our endeavor is to make history a meaningful part of contemporary life. This book, and the books that follow, will help bring this undertaking to life.

If you would like more information regarding this organization or have items you may wish to contribute to our archives, please contact us at McKeesrocks.com.

Also, Paul Stultz, a member of the historical society, has created an extensive Web site relevant to McKees Rocks history and genealogy. Please stop by and visit freepages.genealogy. rootsweb.ancestry.com/~mckeesrocks/.

DISCOVER THOUSANDS OF LOCAL HISTORY BOOKS FEATURING MILLIONS OF VINTAGE IMAGES

Arcadia Publishing, the leading local history publisher in the United States, is committed to making history accessible and meaningful through publishing books that celebrate and preserve the heritage of America's people and places.

Find more books like this at
www.arcadiapublishing.com

Search for your hometown history, your old stomping grounds, and even your favorite sports team.

MADE IN THE

USA